Bryan Wynter

Bryan Wynter

Chris Stephens

ST IVES ARTISTS

Tate Gallery Publishing

cover: *High Country* 1956 (fig.37)

back cover: Bryan Wynter, 1963
(photo: J.S. Lewinski)

frontispiece: Bryan Wynter, 1962
(photo: Peter Kinnear)

ISBN 1 85437 293 9

A catalogue record for this book is available from
the British Library

Published in 1999 by order of the Trustees of the
Tate Gallery by Tate Gallery Publishing Ltd,
Millbank, London SW1P 4RG

Cover designed by Slatter-Anderson, London
Book designed by Isambard Thomas

Printed in Hong Kong by South Seas
International Press Ltd

Measurements are given in centimetres, height
before width

St Ives Artists

The light, landscape and working people of West
Cornwall have made it a centre of artistic activity
for over one hundred years. This series
introduces the life and work of artists of national
and international reputation who have been
closely associated with the area and whose work
can be seen at Tate Gallery St Ives. Each author
sets out a fresh approach to our thinking about
some of the most fascinating artistic figures of
the twentieth century.

Acknowledgements

Much of what follows has been informed by
my broader study of the 'St Ives' artists and I am
grateful to all of the many people who helped
in the research for that project. There are a
number who have specifically provided valuable
information and insight into Bryan Wynter and
his art. Firstly, I owe a special debt to Monica
Wynter who, over a number of years, has
generously provided access to the paintings,
drawings, papers and photographs in her
collection and has consistently answered
countless enquiries with thoughtfulness and
patience. I am grateful for her comments on and
corrections to the text and for her indulgence
of my flights of art-historical fancy. Several
other friends and relations of Bryan Wynter have
given access to letters and been generous with
their recollections. I am grateful to Sue and
Andrew Murray, Eric Wynter, Heddi Fuller, Vera
Hitchcock, Hugh Mellor, the late Patrick Heron,
Paul Feiler, Karl Weschke, Terry Frost, the late
Nessie Graham, Sheila Wynter, Ilse Barker and
Joan Denvir. I must thank the private collectors
and the staff of public collections who gave me
access to works in their care and many of whom
helped with the provision of illustrations. I am
grateful in particular to James Wynter and Carol
Griffin for the efforts to which they went to locate
a specific painting. I was able to trace several
works with the help of Gillian Jason, John Austin
of Austin/Desmond Fine Art, Irving Grose of the
Belgrave Gallery and Madeline Ponsonby and
the staff of the New Art Centre. I also thank Liz
Knowles for generously sharing her research for
a catalogue raisonné of Wynter's work and Pam
Griffin at the Arts Council Library. Bob Berry
kindly provided many photographs of Wynter's
work, and I would also like to thank the Tate
Gallery Photographic Department for their help,
particularly David Clarke, Andrew Dunkley, Mark
Heathcote, Marcus Leith and Rodney Tidnam.
My text has benefited from the comments of
Matthew Gale, Mike Tooby and Jeremy Lewison,
and has been greatly improved by the typically
sensitive editing of Liz Alsop. As always, the book
could not have been researched or written
without the patient support of Jo Willer.

Chris Stephens

Contents

Introduction

Born 8 September 1915, Bryan Wynter belonged to a generation of artists whose careers were delayed by the Second World War. Like that of his contemporaries, his earliest work was rooted in the modernist art and theory of the 1930s, but six years of conflict followed by the horrific revelations of the Concentration Camps and the dropping of two atomic bombs in 1945 annulled the optimism upon which that modernism had been predicated. In the second half of the 1940s and the early 1950s, amid the anxieties of the Cold War, earlier faith in a collective ideal was

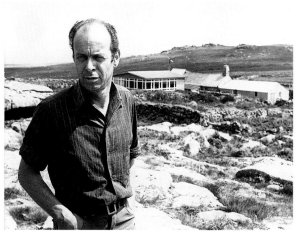

1
Bryan Wynter outside
The Carn c.1962

2
Meeting Place 1957
Oil on canvas
142.2 × 111.7 cm
The Museum of Modern Art,
New York. G. David
Thompson Fund

replaced with a new individualism, which witnessed a renewed interest in mysticism and spirituality and an emphasis upon subjectivity in artistic production. In Britain, Europe and America, painters developed new styles and practices which drew upon and reflected the contemporary preoccupation with questions of existence and the relationships between the individual, society and the world.[1] With those artists, Wynter participated in the reformulation of art for the post-war age.

For him the key to that redefinition lay in ideas of nature and he found it in the life of the landscape of West Penwith – the most distant part of Cornwall, a knob of land extending from St Ives to Land's End. He travelled to Cornwall at the war's end and lived there until his death in 1975. Though a central figure in the busy artistic community in St Ives, for twenty years he isolated himself a few miles out of town in a small house enfolded by the moors above Zennor. The Carn, or Carn Cottage, was seen by many to be at the heart of Wynter's identity and must be prominent in any consideration of his work. That is not to suggest, however, that there was some sort of inevitable causal link between place or the landscape and his painting. His choice of a particular life-style was not the cause of the form that his art took but, like that art, an indication of his broader concerns and interests. Life on the moors afforded personal reflection which, combined with Wynter's love and knowledge of the place and his awareness of both the joyous and the darker side of nature, would provide the source that linked the diverse forms that his art would take over the following three decades.

The term 'nature' is not as straightforward as it seems. Raymond Williams described it as 'perhaps the most complex word in the language' and defined

three different ways in which it is used: as '(i) the essential quality *of* something; (ii) the inherent force which directs either the world or human beings or both; (iii) the material world itself, taken as including or not including human beings'.[2] Wynter's use of ideas of 'nature' and 'the natural' engages with, and plays upon, the tension between these different definitions and with the position of human beings within them.

Nature informed not only the imagery in Wynter's paintings, but also the means by which they were made. Organic processes provided a model for the development of a style of gestural abstraction that secured his reputation in the late 1950s. The resultant paintings were comparable with much of the work emanating from St Ives and consistent with international artistic values dominant at that moment. However, in contrast to some of his closest colleagues' interest in constructivism, Wynter's own roots lay in Surrealism and, in the early post-war years, his painting had developed from that idiom into a neo-romantic style. In the 1960s he produced a series of illusionistic mobiles which revealed his appreciation of the primacy of visual perception in contemporary painting and sculpture, and may thus be associated with the early stages of Op and Kinetic Art. He continued to paint, but the last ten years saw a decline in his reputation and, by the time of his death, the little work he showed in London was largely ignored by the critics.

The following chapters explore the various forms Wynter's art took in a loosely chronological pattern and consider the different ways in which he drew upon ideas of nature as a source. Given the use of place within his painting and the importance of location to the pattern of his career, the account is prefaced by a discussion of his life in Cornwall and its significance for him. The primary aim is to present the breadth of the artist's output and some of the ideas and conditions that may have helped to determine it. If there appears to be a particular focus on the years immediately after the war, it is because of my contention that it was during that time such ideas coalesced. In mapping the development of Wynter's work one should see him not only in isolation or as an important figure in St Ives, but as an artist who was particularly responsive to the issues that informed some of the most advanced art of the period. The reading of the work proposed here is not one that Wynter would have offered, but such a departure from his stated intention might be justified by quoting from the poetry of his friend W.S. Graham:

Or maybe, surely, of course we never know
What we have said, what lonely meanings are read
Into the space we make. And yet I say
This silence here for in it I may hear you.[3]

1
The Flight to Cornwall

Throughout Britain the end of the war in Europe was marked by the celebrations of VE Day on 8 May 1945. Shortly afterwards, Bryan Wynter, then not quite 30, set off on his motorcycle for St Ives. As a registered Conscientious Objector, he had been obliged to spend the previous five years engaged on war work in Oxford. Such was his urgency to escape that he risked arrest by leaving before his official release. With that precipitous decision he set the scene for his subsequent career, the direction of which would be established in the last few months of 1945.

Wynter arrived in Cornwall in the summer and camped on a hill above St Ives. He was enthralled by the landscape, describing it to a friend:

stone walls bursting with ferns and rock plants honeycomb the country into tiny fields and out of this mosaic rise the moors with great round hills covered with bracken and gorse and capped with huge granite boulders. Great stone chimney stacks stride like giants up the hill behind my tent and in the bracken one comes on the concealed shafts of the mines – horrible black wells, some of them thousands of feet deep … the field patterns go down to the coast which is on a huge scale, great rocky points pushing out to sea and between them a steep ravine with a little stream cascading down over the rocks among orange water flowers and red fuchsia bushes.[1]

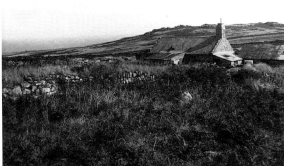

3
The Carn and
surrounding landscape
c.1946

It was on those moors that Wynter would establish himself, and their life of bracken and gorse, granite boulders and cascading streams and ancient field patterns dropping to sea-cliffs would come to provide the raw material for his work; the sinister side of the landscape, represented by the 'horrible black wells' of the abandoned tin mines, would become a recurring theme.

Wynter did not intend to stay in Cornwall. He planned initially to spend the summer there and to return in September to the Slade School of Art where he had studied for two years before the outbreak of war. However, he soon found a home at The Carn, which derived its name from the wind-carved granite outcrop that crowns Zennor Hill, where the house nestles hidden from the road (fig.3). The near-derelict house had been a smallholding with eight acres of poor quality land, though past occupants might also have worked in the mines round about. The moorland on which it stood had, at one time, supported many such small dwellings but by 1945 few remained. The Carn consisted of one large room with a huge fireplace, two smaller rooms and a cow shed which

Wynter would use as a studio (fig.4). Beneath a slate roof silvered by successive cement washes, its thick granite walls were chronically damp. It had neither electricity nor telephone and for water he rigged up a drainage system to collect the rain and plumbed a network of rubber hose. The low-set house seems almost continuous with the land around it and offers views along the moors to east and west. From the rocks behind one can look inland over green valleys to the tin mine of Ding Dong and, to the north, see across the village of Zennor and the cliffs beyond to the span of the Atlantic Ocean. Up there it is almost always windy and, when overcast, the hill is frequently shrouded in cloud. Wynter was, nonetheless, optimistic, declaring that when it was foggy in the village 'I say to myself that up on the Carn it is probably clear & when it is grey down here but clear, the Carn often has its head in a cloud like Mount Olympus'.[2]

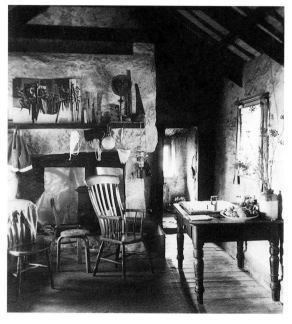

In preparation for his new home, he took up residence in a granite gazebo at the end of the vicarage garden in Zennor and there he planned a life of simple isolation. He wrote to his mother in August, explaining that, though he wanted 'a wireless [to] keep ... in touch with the Big World Outside', life would be frugal and inexpensive – 'food, cigarettes and that is all'. He went on, 'Carn cottage has a garden & I will be able to grow vegetables. There are wild goats on the moor & I am deliberating whether to keep a goat or two for milk, releasing them when I go to London'.[3] He never caught the goat, nor did the vegetable garden ever fully materialise.

He moved into The Carn in September and about six months later met Susan Lethbridge, who would become his first wife. Having moved to St Ives in late 1945, she made hand-made wooden toys and her business, The Toy Trumpet, became a huge success, supplying fashionable London stores and employing several members of the artistic community as decorators. After several years together she and Bryan were married in February 1949 and a son, Jake, was born shortly afterwards.

Wynter lived in The Carn for almost twenty years. In settling there he defined a particular self-image and the house came to be seen by many as the embodiment of him, a single place that encapsulated his character and attitude to life. Though far from unsociable or reclusive, there he could find solitude. He became a lively member of the community of artists in St Ives and made frequent visits to London, but at The Carn he could immerse himself in the landscape and the life that it supported. Described as 'close to the earth, to living, to seeing, to exploring, to inventing',[4] fascinated by animals, by the life of the land and by water, Wynter was forever curious and Zennor Hill provided an arena for his exploration and investigations. In his brother Eric's words, he 'befriended wild animals, climbed the great Cornish cliffs, skin-dived, drank in St Ives pubs and mooched around the moors, coming to know the community of wildlife as an appreciative observer without wishing to take a scientific interest in them'.[5]

4
Interior of the
The Carn c.1946

5
Cornish Farm 1948
Monotype and
gouache on paper
50.8 × 73.6 cm
Private collection

Both this life-style and Wynter's art may be associated with a reconsideration of the relationship between the individual and society that was prevalent at the time. To view his choice of life in a broader context, one might see its origins in his reading of Aldous Huxley's *Ends and Means* (1937). Huxley proposed a reform of the state and society in which the emphasis was on the individual rather than the crowd and on personal development and spirituality. Written against the backdrop of the polarised politics of the late 1930s, such a position, for which Huxley used the Zen term 'non-attachment', may be seen reflected in the rise of enlightened individualism after the war. A 'back-to-nature' life of absolute simplicity was, of course, an established adjunct to the Romantic movement long before Huxley, and it is inevitable that Wynter should have read the work of Henry Thoreau, perhaps the most famous advocate of such a life.

Wynter was a sceptic; despite his pacificism, he was neither religious nor politically committed beyond a cynical distrust of authority and the status quo. 'There is', his brother was able to write, 'a shoddiness in life which you and I have come to accept – the fact that most things are broken, that most aims are corrupt, and most achievements failures.'[6] This attitude, which informed his seclusion on the moor, is typical of the contemporary ideas of Existentialism and especially the nihilism in, for example, Jean Paul Sartre's *L'Age de raison*, which Wynter read shortly after it was published in English in 1947. However, the painter explained his stance in more positive terms: 'cynicism is the necessary complement of idealism. You cannot be an idealist without also being a cynic. You must recognise that people <u>are</u> bloody but redeemable.'[7]

Nevertheless, it would be wrong to see Wynter as po-faced; though sincere and serious, he was never overly earnest. He acquired a reputation as witty and charming, charismatic and humorous, though 'there was a good deal of savagery in his elaborate and bizarre practical jokes'.[8] He was continually

6
Landscape, Zennor
1948
Gouache on canvas
48.3 × 73.7 cm
Arts Council Collection,
Hayward Gallery, London

making things – including a wet suit and aqualung for diving off the coast – and this inventiveness and enquiring mind ensured that his interests ranged widely from literature to canoeing, his own rice wine and home-made rockets, which he was reputed to have fired at passing military helicopters. His friends were thought to have been chosen for their eccentricity, and he surrounded himself with animals, including a pair of tame hedgehogs and a pet raven, named Doom, that attacked the ankles of visitors to The Carn and mimicked Wynter's voice. His brother recalled the range of his conversation: 'he would talk about inventions, people, jazz, poetry, about underwater, about discoveries on walks'.[9] Wynter's attractive character was recorded by many friends, not least in elegies by the poets W.S. Graham and David Wright, the latter describing him as 'The long man who lived on Zennor Hill, the gentle one'.[10]

The war has been described as a time of 'darkness, loneliness and displacement', but the group of artists who settled in Cornwall and were defined by the label 'St Ives' countered that alienation with a sense of community.[11] Undoubtedly, despite his self-imposed isolation, one of the area's attractions for Wynter was the presence of plenty of like-minded neighbours, though he could also become exasperated by St Ives's 'small-town artistication'.[12] Soon after arriving in Cornwall in 1945, he began to secure his position within the network of artists and writers who were gathering in the area. Within weeks of his arrival in July he had befriended Sven Berlin and the Scottish poet W.S. Graham. Having left the army, Berlin was establishing himself as a painter and sculptor and, with his self-consciously romantic image, he came to epitomise an idea of 'St Ives' as a picturesque artists' colony. Sydney Graham was then living with his life-long partner Nessie Dunsmuir in a nest of gypsy caravans on the southern coast of

the peninsular. Though only 27, he had already published three volumes of poetry and provided a valuable link to the group of metropolitan artists that included John Minton, the Roberts Colquhoun and MacBryde and their mentor Jankel Adler. Wynter recorded that when he first visited Graham he met Minton there, whom he then considered 'one of the most gifted painters of my generation, & a person after my own heart' (see fig.21).[13]

In fact Wynter had already had some contact with the artists associated with London's Soho. As a student at the Slade before the war, he had rented a flat in Gower Street and frequented the pubs and cafés where the painters and poets congregated. To understand Wynter, his work and his social contacts it is important to recognise that he maintained these links and continually travelled to London from Cornwall. He had initially intended to divide his time between Zennor and the city and on several occasions spent periods of some months 'in town' having swapped studios with another painter. This was true to a large extent of 'St Ives' in general and the community of artists there was, broadly speaking, intertwined with artistic circles in the capital. So-called artists' colonies have always relied upon good communication with the main sites of artistic exchange and, just as the expansion of the railways enabled the development of such communities in Newlyn and Pont Aven in the late nineteenth century, so wider car ownership and an improved road network was central to the success of 'St Ives'.

'St Ives' would attain a homogeneous image, but in the years immediately following the war the area played host to a relatively diverse group of artists and writers. In the town the dominance of the late English Impressionism of the Royal Academicians was challenged by the burgeoning circle centred on Ben Nicholson and Barbara Hepworth, which then included Peter Lanyon, John Wells and Wilhelmina Barns-Graham. Meanwhile, the community that developed on the moors around Zennor, of which Wynter was a central part, was spurred on by the post-war exodus from London. The painters Colquhoun and MacBryde, Minton, Lucian Freud, John Craxton and the Surrealist Ithell Colquhoun all visited Cornwall. Equally important, the poets George Barker, John Heath-Stubbs, David Wright, Michael Hamburger and John Fairfax stayed for a time in and around Zennor, earning themselves the epithet 'The Moor Poets'. Other like-minded artists settled round about: David Haughton in Nancledra, in the valley to the south of Wynter's hill, and Kit Barker in a similarly decrepid homestead a little to the west. The area was indeed seen as an extension of Soho and was recalled by Heath-Stubbs as 'the sea-coast of Bohemia'.[14]

Wynter joined in the activities that helped to establish St Ives as a major centre for British art while avoiding the internecine politics for which it became renowned. From 1945 he showed at The Castle Inn and in several displays at Downing's Bookshop, both of which contributed to the presence of modern art in the town. In 1946, with Berlin, Lanyon, Wells and the printer Guido Morris, he participated in the first Crypt Group exhibition, so-called because it showed in the basement of the deconsecrated Mariners' Church, beneath the St Ives Society of Artists. Though encompassing a heterogeneous collection of artists, the Crypt announced the advent of a new order within the small artistic community and sought to promote itself beyond St Ives as a coherent group with a common agenda. As its secretary, Lanyon saw it as a means of bringing about change in the St Ives Society and tried to organise an exhibition of the group's work at the Hanover Gallery in London. The following year, Wynter

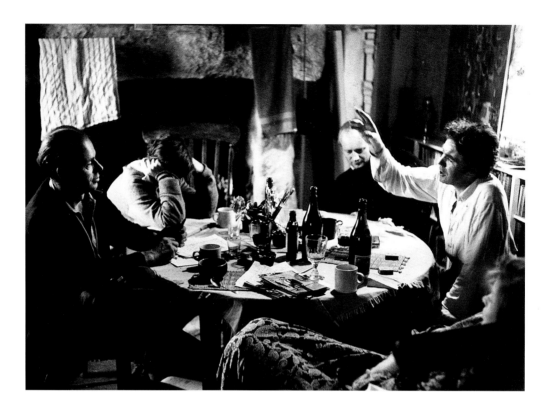

contributed to the St Ives Society's annual exhibition but did not show in the second Crypt Group in August, probably because of his first one-person exhibition at the Redfern Gallery the month before. He took part in their third and final show which was expanded to include Barns-Graham, Haughton, Patrick Heron and Adrian Ryan. Despite this, it is characteristic of his detached position and belief in the individuality of artistic work that Wynter was not involved in the political movements that brought about the split of the St Ives Society of Artists and consequent foundation of the Penwith Society of Arts in Cornwall in February 1949. He did, however, accept an invitation to join from the first meeting of the new society and remained a member until 1960.

With the sponsorship of Hepworth and Nicholson, 'St Ives' would become a major focus of the British art world, gaining unequalled support from both the Arts and British Councils. Though he was already beginning to get established when he moved to Cornwall, there is little doubt that the prominence of 'St Ives' and its efficiency as a patronage network facilitated Wynter's career by the access it afforded him to dealers, collectors and, most especially, to state patrons. In April 1945 he had been invited to exhibit at the Redfern Gallery and, despite an almost immediate change in style, he had his first exhibition there in July 1947. This was followed by a further five before a row, precipitated by the gallery's unease with abstraction, prompted him to join the newly established Waddington Galleries in 1958. There, with Patrick Heron, Terry Frost and Roger Hilton, he became part of what was termed 'The Middle Generation'. By that time Wynter was regularly included in the numerous international exhibitions toured by the British Council. Like many of his 'St Ives' colleagues, he enjoyed the friendship of Lilian Somerville who, as director of the Council's visual art department, was a major power in the British art world. From 1951 his work was

7
Late-night gathering at The Carn c.1957
From left: Bryan Wynter, unknown, Karl Weschke, W.S. Graham, Monica Wynter

seen in countries as diverse as Spain, the United States and Canada, the USSR, Hungary, Israel, Tunisia, Kenya and Iraq. He also benefited from the fact that 'St Ives' as a collective phenomenon was particularly attractive to the Arts Council which, in the first years after the war, sought to promote a regional creativity of which the Penwith Society was seen to be exemplary.

Its fame ensured that the later 1950s were the heyday of 'St Ives' and Zennor became a locus for a new form of gestural abstract painting based on land-scape. In 1955, Patrick Heron – by then a respected painter and critic – became Wynter's neighbour when he bought Eagles Nest, a large house below The Carn. The following year, Graham, who had left the area in 1946, returned to live in a coastguard's cottage at Gurnard's Head, beyond Zennor. Other artists colonised the moors: John Tunnard, for example, moved from the Lizard to Morvah; Anthony Benjamin bought Berlin's cottage at Cripplesease; and a friend from London, Karl Weschke, came on Wynter's instigation to live nearby at Higher Tregerthen, where D.H. Lawrence and his wife Frieda had spent the First World War until hounded out by the locals and the authorities. Roger Hilton, who became a close friend of Wynter's, regularly rented a house over the hill from The Carn at Nancledra until moving permanently to Botallack, near St Just-in-Penwith, in 1965. Wynter's friends were not drawn exclusively from the artistic community, however, and included, in particular, many of the neighbouring farmers.

Clearly he was not alone in seeking refuge in the wild periphery. His move to Zennor and the similar journeys made by many artists were part of a larger outward migration from the metropolitan centre. Even before the war, the 'Celtic fringe' of Cornwall, Wales and Scotland was the site for a recommitment to indigenous cultures while also providing a substitute for the exoticism of abroad. The escape to a perceived simple rural life was a recurring feature of modernism and became all the more urgent after six exhausting years trapped in ration-bound, bomb-ravaged cities. This was not simply a question of personal preference or financial expediency, but an identification with a particular set of ideas and values.

Early in the war Cyril Connolly, the editor of *Horizon* – the major cultural journal in 1940s Britain – had held D.H. Lawrence up as the epitome of the outsider, the principled opponent of the status quo, a romantic rebel who, 'like Keats, was broken by England'. In the Great War Lawrence had gone to live on the moors near Zennor and Connolly speculated on how he would have spent this Second World War. 'Would he be in the Ministry of Information or the Home Guard?' he wondered; 'No, he would still be at Zennor, still be persecuted for his beard and his painting and his ex-German wife.'[15] When he moved there, Wynter found that Lawrence was 'almost a legend in the district',[16] and he may be seen as a persistent, if largely unacknowledged, model for the construction of identities within 'St Ives'. As a modernist who sought out the 'primitive' in his life-style, art and attitude to sexuality, Lawrence stood for a certain integrity, and the adoption of his moorland life by Wynter and others can be seen to reflect a similar rejection of bourgeois norms. As Wynter wrote to his mother, 'What for you would be "amenities" are just a nuisance to me. The Carn pro-vides me with my own particular brand of amenities, an enormous access to & experience of this wild corner of England which still holds out against the slow insidious invasion of garden suburbs and slum.'[17] The adoption of a life of oil-lamps and self-sufficiency became all the more marked during the 1950s, as Britain emerged into a time of growing consumerism and domestic comfort.

There was certainly a pursuit of ideas of innocence and authenticity in the migration to the moors. In going to Cornwall, Wynter, like many of the artists who would gather there, returned to a favoured place from childhood. His family had regularly holidayed there in the 1930s, travelling around West Penwith and visiting Zennor and the surrounding landscape. Cornwall had become a desired object some time before the war's end: he had returned to St Ives with his brother in 1942, looking out for potential homes, even though he found it 'rather an "arty" town still with its "Bo'emian rendez-vous".[18] The diary he kept for a few months in 1945 shows that he dreamt of Cornwall on several occasions before moving there. Following a dream in which St Ives appeared like Zurich, Wynter noted that for him both places were 'symbols of war-free towns'.[19] For several other people too, West Penwith was seen as a site for personal renewal after the war. As a Cornishman, Peter Lanyon demonstrated the importance of his return home with a series of works on the theme of 'generation' and Sven Berlin, whose mental breakdown ensured his release from the army, announced his recovery in the catalogue of his first exhibition: 'The war took everything and left only the wasteland. Coming back we were as Lazarus. What did I do but sit on an island and carve stones, learn the shapes of shells and leaves again, textures of rock, nature of light and movement, as if I were coming to life for the first time.'[20] Though he had not been to war, one may view Wynter's move to Cornwall and immersion in a natural environment in a similar light.

Specifically, his migration was set against a personal crisis which had come to a head at the end of the war. He saw himself as 'divided and unsure'[21] and in response to a feeling of deep depression embarked on a three-month period of Jungian analysis while still living in Oxford. However, it was in Cornwall that he felt he had found the answer to his problems, writing from there that the isolation was 'very helpful in collecting myself. All the scattered bits of my personality which were getting out of hand are gradually reassembling and forming a whole and this pleases me, as it was the chief motive of coming down here.'[22]

There were several reasons for Wynter's depression, including the nature of his wartime activity and the long-running tensions between him and his family. Though fond of his mother and close to his brother, relations with his father were, at best, strained. The antipathy between them seems to have originated from 3-year-old Wynter's indignation at the return from the Great War of a father he did not know and his resultant jealousy for his mother's hitherto undivided attention. Throughout his life he would instinctively adopt an anti-establishment position that might well be related to his rejection of the bourgeois values for which his father seemed to stand.

James Wynter was the wealthy, upper-middle-class head of the family business – The Times Laundry Company – that had originated in Yorkshire under the name of Winterbotham. The family home, 'Windyridge', was near Hertford, where they also ran a farm, as much as a hobby as a business. He had wanted Bryan, who was his eldest son, to follow him into the firm after a private education. Bryan spent about five years in laundry, including a period in Zurich studying new technology, before his father succumbed and let him attend the Slade School in 1938. Despite this acquiescence and the granting of a modest allowance after the war (roughly the wage of a local labourer), relations between father and son remained forever strained.

Wynter was still at the Slade when it was evacuated to Oxford's Ruskin

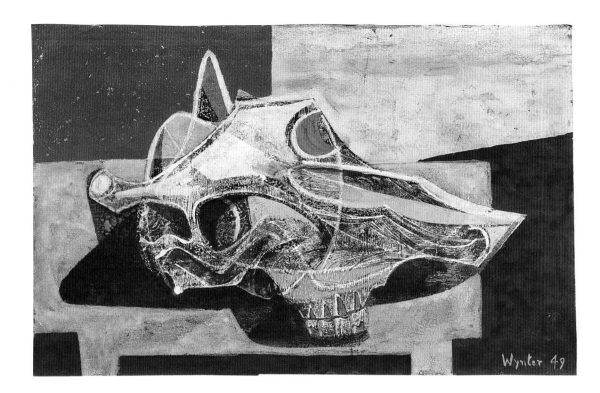

8
Ox Skull 1949
Monotype and
gouache on paper
25 × 44.5 cm
Jonathan Clark

School in 1940. He registered as a Conscientious Objector and was given a conditional exemption from active service and required to take on war work. After digging ditches and market gardening, he and Slade colleagues Hugh Mellor and Vera Leslie applied successfully to look after the laboratory animals at the Department of Human Anatomy run by Professor Solly Zuckerman. The job was menial – feeding and cleaning monkeys' cages and preparing them for the experiments to which they were subjected. The principal work of the laboratory was research into hormonal effects, with a particular interest in their sexual role, and many of the monkeys were killed for dissection. Mice were subjected to explosions to study the effects of blast on bodily organs, and with characteristic cynicism Wynter suggested that when the British were losing in the war this research aimed to minimise damage done to the human body, but when they were winning the object became to increase it. Ultimately, the work was dispiriting and the cruelty became increasingly wearing. It was against this depressing backdrop of vivisection that the long years of the war brought Wynter to a point of crisis, a feeling that was exacerbated by his desire for personal space and independence. More generally, his sense of personal fragmentation may have been powerfully compounded by doubts raised over Conscientious Objection to the war by the horrors revealed in the concentration camps.

The artist interpreted some of the pictures he produced in his first few years in Cornwall with direct reference to this troubled state of mind. The work, largely gouache on paper, consisted of Cornish landscapes and depictions of animals. Amongst the latter were cockerels, crabs, crayfish, bulls, goats and the skulls of sheep and cows (fig.8) and especially birds, most particularly seagulls (fig.10). Clearly indebted to the work of Picasso (specifically

17

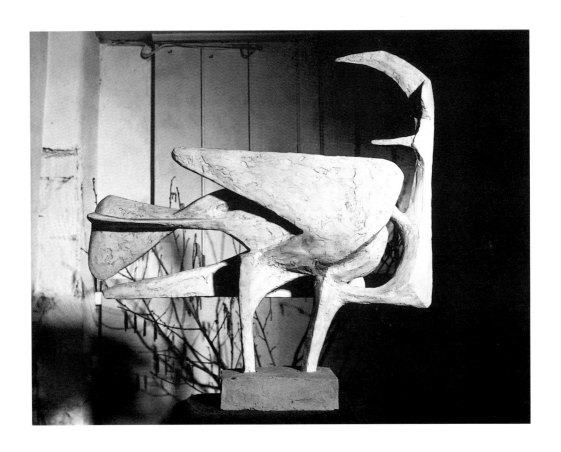

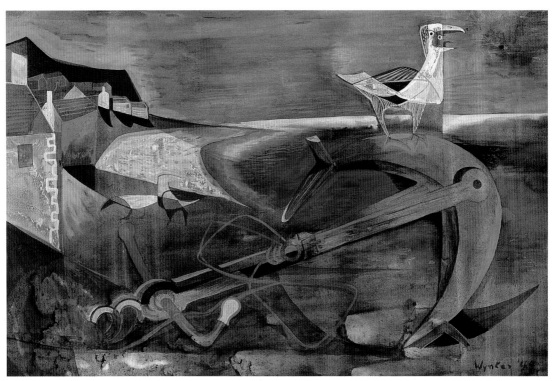

Guernica and the related works which Wynter had seen in London in 1938), the gulls strut or stand, posturing, while others circle in the air aggressively (fig.11). Based on close observation, the birds, often rather ridiculous, also seem to parody human failings, becoming caricatures of figures of authority or, like Graham Sutherland's Thorn Paintings of the same period (fig.31), emblems of cruelty and suffering. The duality of humour and aggression is, perhaps, especially evident in a rare sculpture that Wynter made a few years later (fig.9).

It is tempting to see in an image such as *Birds Disturbing the Sleep of a Town* 1948 a statement of defiance or revolt. It seems like a satire on the cliché of swirling gulls that had populated countless paintings made in Cornwall between the wars. In contrast to those, Wynter's ghostly birds circle threateningly like bombers above the polite little harbour, their cries upsetting its status quo. The painter uses the formal structure of the painting to distance himself from the town as, through the spatial division of the figures of the birds from the pictorial ground, he is located in the domain of a dominant, brutal nature as opposed to the picturesque civilisation below.

The tone, however, is rather different in a number of works which show dead gulls, some rotting, others whose plunging forms powerfully enhance their sense of pathos (fig.12). The motif had been established as a symbol of sacrifice for love in Anton Chekhov's play *The Seagull* and was reused by George Barker, shortly after his time in Zennor, in his novella *The Dead Seagull* (1950). In this story of sexual infidelity and Catholic guilt, which resonates with Coleridge's *Rime of the Ancient Mariner*, the dead gull features as symbolic retribution for the erotic sins of the protagonists. The dead bird was a theme in

modern painting also: it had been used, for example, by Salvador Dalí – a hero of Wynter's – in the 1920s; more contemporaneously, the American Morris Graves's use of the motif had been reproduced in *Horizon*[23] and it appeared in the contemporary work of Prunella Clough and, most particularly, of Lucian Freud. After the war there was considerable interest in the paintings of Chaim Soutine, in which dead animals were a recurring motif and one such work was owned by Wynter's Crypt Group colleague Adrian Ryan.

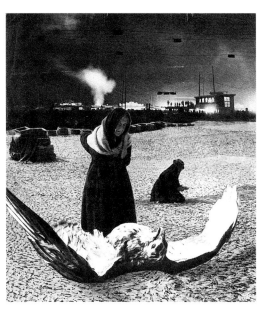

Wynter interpreted the frequency of the dead gull motif in his work in terms of Jungian symbolism, in which birds are identified as representations of the spirit.[24] He thus saw its recurrence as an unconscious symbol of his spiritual death or, perhaps, his mundane state. For Jung, the bird in flight is a symbol of transcendence and release and so, by extension, Wynter might have seen a painting like *Birds Disturbing the Sleep of the Town* as a celebration of vitality. This is borne out by Sven Berlin's recollection of the painting's genesis:

when I asked [Bryan] about it he told me that he had been looking down on Zennor one night feeling suicidal. Suddenly the curlews flew over in the moonlight giving their fluting calls. 'After that', he said, 'everything seemed worthwhile again and I painted this.'[25]

12
Dead Gull 1947
Gouache on paper
37 × 25.4 cm
Private collection

13
Untitled c.1949
Photomontage
29 × 26 cm
Private collection

This contrast between the theme of degradation or decay and that of transcendence through nature appears in much of Wynter's work of this period and after.

As with all art, these works are not simply expressions of the artist's subjectivity, but might also be seen to address and reflect the times in which they were made both as part of his intention and, unconsciously but inevitably, as artefacts of a certain historical moment. That Wynter saw the dead gull motif as more than either a natural 'found object' or a reflection of the self is suggested by one of a group of photomontages that he made at the end of the 1940s (fig.13). Though never intended for exhibition, these collages were displayed at home or in the studio. They are made up of fragments from *Picture Post* and, even though these originated in a diversity of contexts, the works retain the atmosphere of economic hardship and cultural disturbance in post-war Europe that was a feature of the magazine's photography. A bird lies prostrate on a stretch of beach or waste land, observed by one of two peasant women, and the whole scene seems to be overlooked by the conning tower of an industrial complex. The symbol of the dead gull thus enters into the imagery of social deprivation and an ominously surveillant industrial modernity. In that way, what Wynter interpreted as a signifier of his spiritual self becomes, also, symbolic of the threat of modern social forces. Though probably unintended by the artist, such a sub-text might be read into much of his work. Nature and the landscape can be seen to represent, symbolically, social decay whilst also offering a means of escape and, arguably, transcendence.

2
Towards a Landscape without Views

When Bryan Wynter went to Cornwall in June 1945 he had already achieved his first public success. Earlier that year a brief profile of the artist had appeared in the Oxford-based *Counterpoint*, a short-lived, but nonetheless significant, neo-romantic journal.[1] Two pictures, clearly influenced by the nightmarish compositions of the surrealist Max Ernst, were reproduced, one in colour (fig.16). The images, later described dismissively by the artist as 'traumata',[2] were typical of his work between 1943 and 1945 and consisted of nests of intermingling birds, rearing aggressively against a violently coloured sky. They prompted an invitation from Erica Brausen to exhibit at the Redfern Gallery.[3] Despite this sign of approval, Wynter's style soon changed and the range of works from 1945–7 suggests a degree of uncertainty. Though his move towards a more representational style was in line with a general trend in artistic production in the 1940s, he attributed that change to his move to West Penwith.

Before and during the war Wynter's work was largely indebted to Surrealism. The irrational and irreverent art of the Surrealists was relatively familiar to an informed London audience through books and exhibitions and Wynter had encountered it in Herbert Read's *Art Now* (1933) and *Surrealism* (1936) and David Gascoyne's translation of André Breton's *What is Surrealism?* (1936), all of which he owned. He probably saw the *International Surrealist Exhibition* at the New Burlington Galleries in June 1936 and, certainly, as a student in London from 1938, used to see such work at the Mayor Gallery and in reproduction at Zwemmer's bookshop. He particularly admired the dream-like imagery and fantastic creatures of Salvador Dalí and Max Ernst. In a rare painting from the 1930s (fig.14), a group of clearly gendered, intertwined, serpent-like anthropomorphs become entangled in barbed wire in what was perhaps a satire on contemporary politics and the build-up to war. The forms reveal Wynter's debt to Picasso but are also reminiscent of the cartoon figures of Tex Avery, the great American animator. The scene appears humorous rather than aggressive, but other pictures strike a more bitter note. One, ironically entitled *The Science of Life* 1945 (fig.15) shows two creatures devouring each other and can be compared to

14
Fantastic Figures Imprisoned by Barbed Wire 1937
Coloured crayon and pastel
37.5 × 55.2 cm
Victoria and Albert Museum, London

15
The Science of Life 1946
Pencil and watercolour
22.9 × 30.5 cm
Private collection

16
Birds c.1943
?Gouache on paper
c.76 × 50 cm
Whereabouts unknown

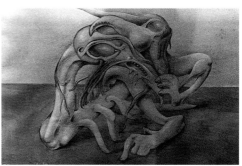

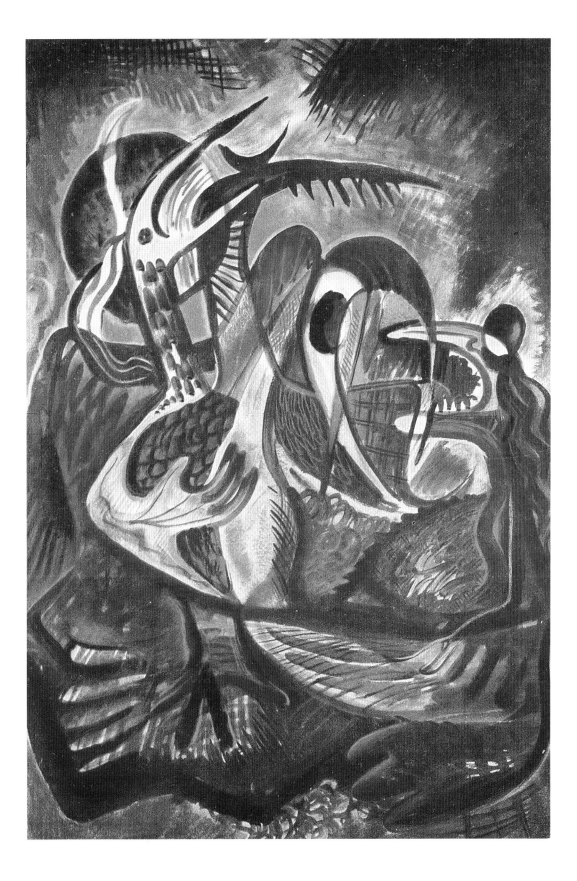

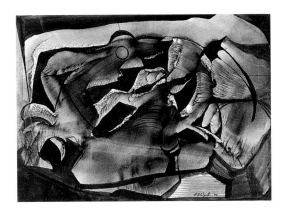
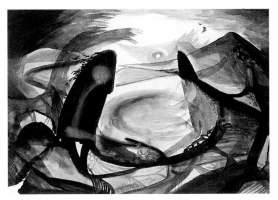

Dalí's *Autumn Cannibalism* 1936–7, which depicts a similar act of grotesque mutual consumption, a comment on the Spanish Civil War.

In Oxford during the war Wynter had little time to paint, but produced a number of surrealist drawings and others of the town for which he reverted to a traditional style. His interest in modern art and the ideas behind Surrealism would have been encouraged by his friend Heddi Hoffmann, whose family, as Communists, had fled from Germany to Prague and on to Britain. While she too worked in a surrealist manner, her father was the German Expressionist painter and sculptor Jürgen Hoffmann who had been closely connected with Oskar Kokoshka in Dresden and also linked with Dada artists, specifically Kurt Schwitters. Such connections would surely have interested Wynter who before the war made photomontages reminiscent of the political satires of the Dada artist John Heartfield. In his Oxford drawings the surrealist influence took different tones: some depict anomalous, dream-like scenes in a naturalistic style while the majority show the fanciful birds of the *Counterpoint* picture. The former may be related not only to artistic models but also to Wynter's reading at that time of Sigmund Freud and Carl Jung's writing. Specifically, by July 1944 he had read Freud's *Interpretation of Dreams* and Jung's *Psychology of the Unconscious* and *Modern Man in Search of a Soul*.[4]

In the atmosphere of the war and the years that followed, Jung's reassuring communality and focus on a spiritual dimension overtook Freud's concentration on individual neuroses. In particular, his theory of a collective unconscious, which argued that the recurrence of similar mythic themes in different cultures was an indication that all human beings shared subconscious notions, provided a theoretical framework which united contemporary subjectivity with the past and with a global community. A major and persistent theme in Jung's work is the question of the relationship of the individual subject to the objective world and, in relation to that, he addressed the question of the spirit. This was most clearly signalled in the title of *Modern Man in Search of a Soul* which was echoed by several writers who sought to address the perceived problem of modern man's spiritual death.

When first in Cornwall, Wynter made drawings and watercolours of the countryside and, in particular, of the houses, tin mines and ancient stones, such as Lanyon Quoit, which punctuate it. Focusing on the rock formations and cromlechs, he seems to have deliberately sought to escape from his earlier manner, moaning at one point, 'birds are beginning to emerge from my rocks. Isn't it dreary.'[5] His style varied from representational depictions of specific buildings to more stylised renditions. One ink-wash drawing from

17
Landscape 1946
Ink wash on paper
24 × 33.2 cm
Fitzwilliam Museum,
Cambridge

18
*Landscape with
Watery Moon* c.1946
Ink wash on paper
33 × 56.5 cm
Private collection

19
Fish 1946
Monotype and
gouache on paper
17.8 × 30.5 cm
Private collection

1946 (fig.17) is almost totally abstract, though the black framework and patterns of black wash combine to form an image suggestive of both body and landscape. Another ink drawing of the same period (fig.18) clearly depicts a moorland setting, though its stylisation accentuates its sinister sense of mystery. In both content and manner, it is reminiscent of paintings by John Tunnard and Ithell Colquhoun, both of whom were associated with Surrealism and used the pagan associations of the Cornish landscape in their work.

For a moment, it would seem, Wynter was unsure of the direction in which to develop his art. He was painting in oils in 1945–6 (and was critical of the neo-romantics' reliance upon watercolours), but the fact that few survive suggests that they were unsuccessful and destroyed. For the next five years his paintings were largely on paper, executed in a neo-romantic style especially reminiscent of the angular sculptural forms of Michael Ayrton. They might be seen as late-Cubist landscapes and, as such, as equivalents to the stylised figures of artists like Robert Colquhoun and, in France, Edouard Pignon. For a short time, in 1948, their arrangement and brighter palette would also reflect the impact on post-war painting of the more recent work of Georges Braque, one of the pioneers of Cubism. Wynter's subjects were either landscape, still-life or animals. The first of these tended to focus on a building or small hamlet or else to present a wider span in which human structures seemed to be subsumed into the land. The still-lifes included some domestic paraphernalia but were mostly of dead animals, especially fish and most particularly crustacea like prawns and crayfish (fig.19).

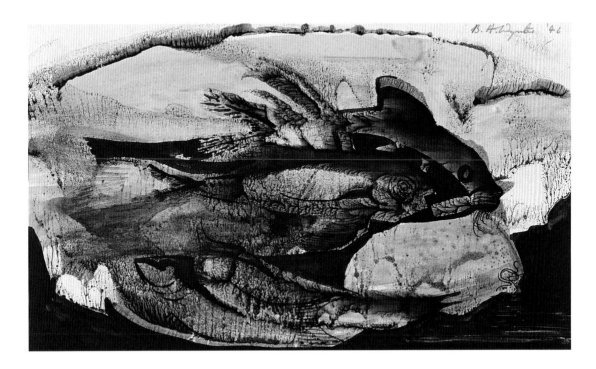

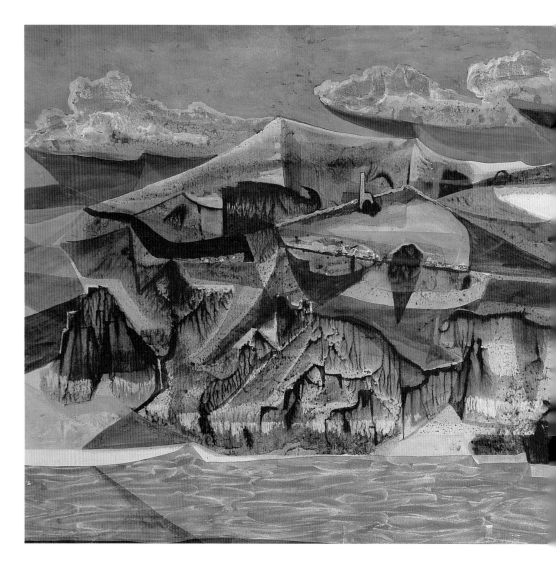

20
Zennor Coast from the Sea 1949
Monotype and gouache on paper
33 × 73.5 cm
Private collection

In the summer of 1945 Wynter articulated not only the attraction for him of the Penwith landscape but also the way he saw its particular characteristics informing his art:

I mentioned as a theory of art the linking up of the inner and outer worlds, as though it were a question of breaking down an artificial barrier and experiencing the two on the same plane at once, seeing it not in terms of inner and outer, of observer and the thing observed, but as one thing – the 'experience', probably the only humanly possible approach to reality. Well here, in this landscape, even when you are not drawing or painting, it happens quite of its own accord. The real landscape overflows into the unconscious and the unconscious wells up peopling the real landscape with its own images.[6]

Thus he does not appear to have seen his adoption of landscape as a departure from earlier concerns, as its union with the unconscious suggested a continuation of his surrealist theory. He wrote, 'If Dalí had been a Celt this is the kind of landscape he would have painted', probably referring to the Spaniard's metamorphic, hallucinogenic use of the landscape at Cadaques.[7] Wynter's view of the land was complex: he saw it as the arena and product of natural process,

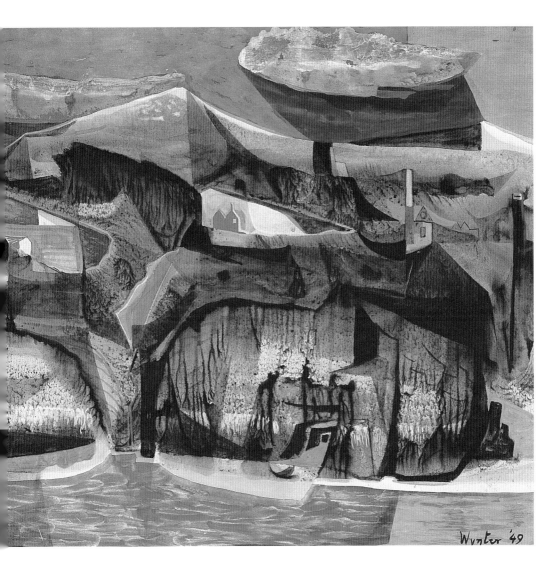

the embodiment of its own history and that of its past human occupants, as a pleasurable place and as a site of cruelty and of darkness – nature red in tooth and claw. As his statement indicates, in depicting it in this variety of ways, he addressed his own subjectivity as much as the nature of the place.

The Surrealists continued to exert an influence over his working practices as much as his concept of art. The obvious precedent for the bird images of 1944–5 was the work of Max Ernst and he remained a source of inspiration, particulary for technique and the use of chance. Wynter experimented with *frottage* – the creation of surface pattern by the rubbing of charcoal or pencil on paper laid over a textured surface. The images are determined by the patterns generated by the process and may be seen as indicators of the repetition of natural forms in microcosm and macrocosm, as seen, for example, in water patterns derived from a rubbing of woodgrain. Wynter's observation that in nature 'the same shapes and characteristics mark the small things as well as the large', that the universal might be found in the minute, echoed the Romantic concept that was expressed by William Blake as 'seeing the world in a grain of sand'.[8]

More than that, Wynter was fascinated by the technique of *decalcomania*, which Ernst had learnt from Oscar Dominguez, with which a varied, mottled effect is achieved by pressing paint between two surfaces and pulling them apart. The fluid patterns produced by such a practice can be seen to have provided the initial ground for most of his paintings of the later 1940s. The technique is a form of monotyping – the production of unique prints – and should be seen as part of a wider revival of the practice in Britain, stimulated by Jankel Adler and witnessed in the work of other artists like Robert Colquhoun and Prunella Clough. Paint was applied to a sheet of glass and the design drawn into it with a sharp point, a brush or a cloth. Thus, an image could be preconceived (though in reverse) while the resulting surface

quality, which provided the underlying pattern for Wynter's gouaches, remained subject to chance. Again, the relationship between random techniques and the organic forms generated by them could be seen to reflect a certain order in natural patterning. For example, in *Zennor Coast from the Sea* 1949 (fig.20) the off-set black paint provided a ground that mimics the striations of the cliff. In such a work the monotype was a starting point for the final image, much of which was painted over it in gouache. Except for the works on canvas, this was the working method employed for most of the landscapes (and still-lifes, for that matter) between 1946 and 1951 and the glutinous effect of the off-set ground invested them with an organic fustiness.

A black and white all-over design like that of Wynter's monotypes had become a feature of the work of several contemporary artists, such as Minton and Craxton (fig.21), and derived ultimately from the visionary landscapes of Samuel Palmer. With that of Blake, the recovery of Palmer during the 1930s had been seen as part of a revival of a British artistic tradition in the face of the threat to national identity from international modernism and war. In 1942 Graham Sutherland, the dominant figure of neo-romanticism, had compared the surface quality of his pictures, which was similar to Wynter's, to the vegetal rocks on which Newton sits in Blake's painting.[9] This all-over organic quality was thus located within an English romantic tradition.

Sutherland's landscapes were seen as festering and bleak, and the same might be said of Wynter's, which are generally punctuated by a human presence – a house, hamlet or church tower – but one which seems as much threatened by the land as nurtured by it. The places which Wynter depicted are peppered with signifiers of dereliction: run-down cottages enfolded by the land, rotting machinery, and melancholy engine houses of disused tin mines (fig.22). Picturesque ruination is a basic element in the iconography of Romanticism as epitomised by the British landscape painters of the eighteenth and early nineteenth centuries and revived by such artists as John Piper shortly before the Second World War. The presence of these ruins contributed to the definition of West Penwith as picturesque and to its consequent assimilation into a tourist aesthetic. At the same time, Wynter's paintings should be seen in

21
John Minton, *Summer Landscape* 1945
Private collection

22
Landscape with Tin Mines 1947
Monotype and gouache on paper
22.3 × 28.5 cm
Private collection

23
Derelict Boiler 1947
Gouache on paper
30.5 × 52.1 cm
City of Bristol Museum and Art Gallery

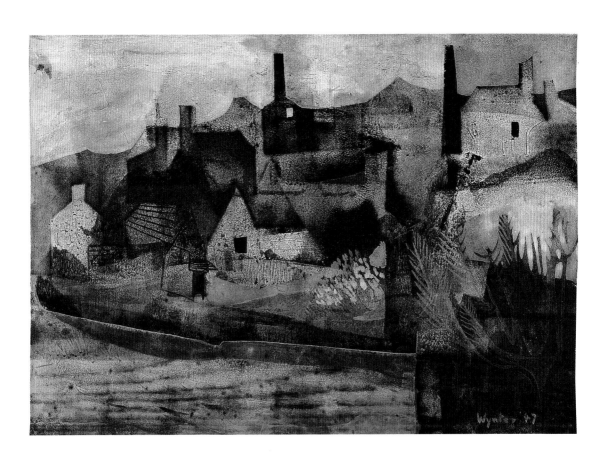

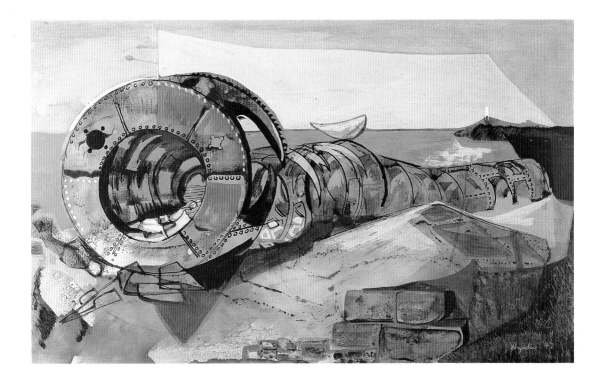

relation to the images of ruins that proliferated during and after the war. For example, photographs of bomb damage by Cecil Beaton and others were repeatedly published in *Horizon* and such scenes famously provided powerful motifs for artists like Sutherland, Piper and Minton. Like these and the dead birds discussed earlier, the crumbling, languid form in a work like *Derelict Boiler* 1947 (fig.23) may be seen as symbolic of a less specific cultural (and personal) collapse, fitting with the definition of neo-romanticism as an 'aesthetic of decline'.[10]

Despite its appearance as a relatively unspoilt wilderness, the area west of St Ives is in essence a post-industrial landscape. Though largely depopulated by the 1940s, at the height of the Industrial Revolution it had been one of the busiest areas of Britain and it was the density of the working-class population that had attracted John Wesley to the area. Cornish tin mining had been in decline since its heyday in the 1870s and, despite a brief fillip during the war, had virtually disappeared by the 1940s. Similarly, the smallholdings that dotted the countryside and whose tenants had farmed the steep, rock-strewn land had mostly been abandoned as the changing patterns of agriculture rendered them uneconomic. Thus, the area was (as it continues to be) financially deprived and we can see Wynter's depictions of a landscape of dereliction and decay as, on one level, a reflection of a contemporary social reality.

When first living in Zennor, Wynter remarked upon the way nature took over the man-made world, returning it, in a sense, to its origins:

history and prehistory irrupts everywhere so that the present appears a recent growth upon the past whose bones project wherever you go; the roofless miners chapel with a tree growing in it and crawling with ivy, the tin mines and miners cottages where once men were busy. Everything goes up in stone, and being stone, remains, overgrown and taken over by the vegetable kingdom.[11]

The idea of a consuming plant life, which had been explored in the French cultural journal *Minotaure* in the 1930s, was central to neo-romantic culture, from Sutherland's organic figures to John Wyndham's novel *The Day of the Triffids* (1951). It, and the concept of a landscape that incorporates or reflects its past and present life, would remain as themes in Wynter's work, reflecting a belief in man's subordination to the natural world.

In many of the pictures the technique itself contributes to the signification of decay and a conquering nature, as the organic fluidity of the monotype serves to unite figure and ground. Just as the ruins of the mines, chapels and abandoned cottages become overgrown, so they and the landscape are locked into a single pictorial plane. In a comparable way, the technique and resultant motif might be related to Wynter's self-fashioning as physically and psychologically immersed in the landscape. The wedding of the figures of the ruined buildings with their ground may be seen as a parallel to the artist's search for a reunification with nature. It is as just such a search that one should view Wynter's move to The Carn and these early landscapes should be seen, not simply as illustrations or by-products of that process, but as necessary elements within it.

The perception of the landscape as a historical record was a feature of much of the art made in St Ives. Hepworth compared her sculptures of the period to the monoliths in this 'pagan landscape' and Lanyon's work was based upon the historical experience of a place. The idea of the land as a palimpsest, a document on which its own history has been repeatedly inscribed and erased, was also reflected in such books as Jaquetta Hawkes's *A Land* (1951) and

W.G. Hoskins's *The Making of the English Landscape* (1955). It was prominent in the Festival of Britain exhibition in 1951, where it took on an explicitly nationalistic dimension, and it can also be associated with a desire for a return to myth and a collective identity. After the war, there was a resurgence of interest in *The Golden Bough* – James Frazer's comparative account of myths of different cultures – but it was the writings of Jung on the relationship of the individual spirit with society that were especially popular with artists in St Ives, as they were among painters in New York.[12]

Wynter, in common with many others, read key texts in a literature that saw social and individual decay in modernity and which promised individual integration within a renewed communitarianism. Amongst the authors he read was Erich Fromm, a Marxist psychoanalyst who examined the relationship of the individual to capitalist society. He identified a process of increasing 'aloneness' and 'individuation' since the Reformation and argued that, amid the paraphernalia of modernity, man had lost touch with himself: 'While creating new and better means for mastering nature, he … has lost the vision of the end which alone gives them significance – man himself.'[13] At the same time, in *The Condition of Man*, Lewis Mumford mapped out the development of 'man' through history, identifying the time of writing as the end of a period of expansion and the threshold of an era of humanisation. He too saw a process of alienation in modernity and predicted that 'The theme of the new period will be neither arms and the man nor machines and the man: its theme will be the resurgence of life, the displacement of the mechanical by the organic, and the re-establishment of the person as the ultimate term of all human effort.'[14]

In line with these ideas was an interest in a variety of forms of spirituality and mysticism. Wynter and his circle studied eastern religions, especially Zen and Tao, reading such texts as the *Tao Te Ching* of Lao-tzu as well as early Christian mystical writings, such as *The Cloud of Unknowing*. Models for such concerns included Huxley, who published an anthology of spiritualist texts in 1946, and, more locally, the potter Bernard Leach who had spent many years in Japan and was a practising Baha'i.[15] Alongside Wynter's study of nature, these interests served as tools in the search for what he apparently termed 'wisdom-knowledge'.[16]

Another major influence on the life and work of Wynter and his circle at that time was Robert Graves's *The White Goddess*. An examination of poetic myth, this extraordinary book is a post-nuclear warning for a return to natural relations in contrast to modern rationality. The language of poetry, Graves proposes, is tied in with the ceremonies of the Muse or the Moon-goddess but its function has been forgotten. Poetry used to warn man,

that he must keep in harmony with the family of living creatures among which he was born … [but] it is now a reminder that he has disregarded the warning, turned the house upside down by capricious experiments in philosophy, science and industry, and brought ruin on himself and his family.[17]

Wynter echoed this view when he stated that 'the spiritual onus of mankind had fallen on the artist',[18] and it is in the light of this that we should view his studies of nature and those of his colleagues.

One might also associate Graves's book with a persistent sinister aspect in Wynter's art and attitude. Despite his amiability, people observed a cruel streak and a fascination with the macabre that might be discerned in his painting. Like Sutherland, he highlighted the brutality of nature and the dark side of the landscape. Wynter wrote with a certain relish about the haunted reputation of

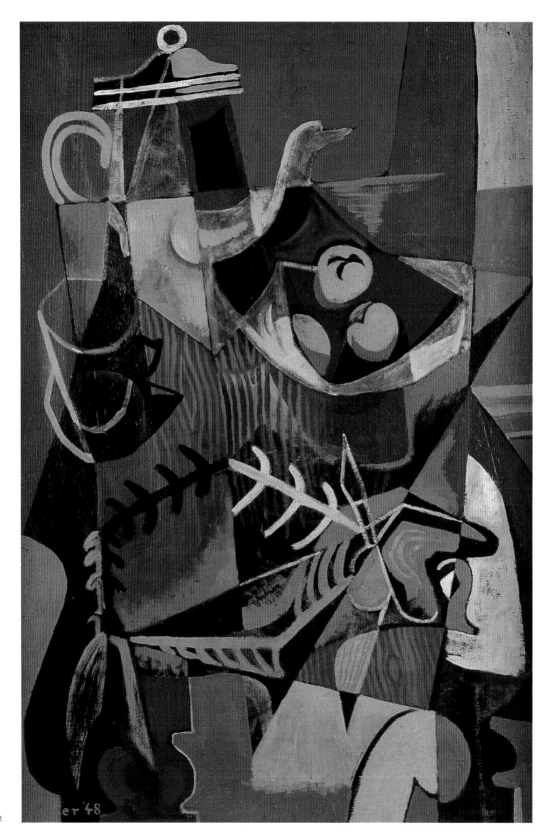

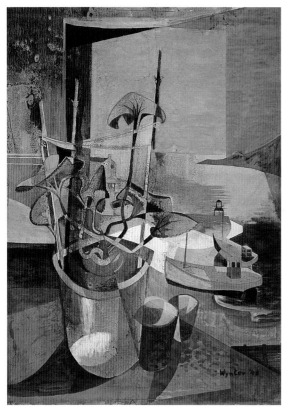

24
Still Life with Kipper
1948
Oil on board
76.2 × 50.8 cm
Private collection

25
Cyclamen 1948
Monotype and
gouache on paper
45.7 × 31.8 cm
Scottish National Gallery of
Modern Art, Edinburgh

The Carn, and Zennor's earlier association with the infamous occultist Aleister Crowley fuelled such stories. In this the artist set himself in line with an established literary construction of the Zennor landscape. 'Nowhere', wrote D.H. Lawrence, 'can it be as black as on the edge of a Cornish moor, above the western sea, near the rocks where the ancient worshippers used to sacrifice', and he went on to describe the rocky outcrops, such as Zennor Carn, as 'pale-grey granite masses, so ancient and Druidical, suggesting blood-sacrifice'.[19] John Heath-Stubbs, a neighbour of Wynter's, adopted a similar tone, writing of the area and its inhabitants:

This is a hideous and a wicked country,
Sloping to hateful sunsets and the end of time,
Hollow with mine-shafts, naked with granite, fanatic
With sorrow. Abortions of the past
Hop through the bogs; black-faced, the villagers
Remember burnings by the hewn stones.[20]

Reviewing his exhibition at the Redfern Gallery in 1948, Wyndham Lewis pointed up the gothic aspect of Wynter's paintings when he wrote enthusiastically of their 'masks and skeletal shapes'.[21] The number of works in, and sales from, his first one-person exhibition had demonstrated his success, while this second showing revealed a stylistic development. *Still Life with Kipper* 1948 (fig.24) could be compared with the tilting, interlocking and fragmented forms of Juan Gris, and Wynter must have known the recent monograph on the Spanish Cubist because David Lewis, then living in Zennor, had assisted its author, Douglas Cooper. But Heddi Hoffmann recognised the major influence when she exclaimed on seeing the 1948 paintings (fig.25). 'What has Braque done to you?'[22] Wynter had seen the Georges Braque exhibition at the Tate Gallery in April 1946 and in September bought the luxurious book on the artist published by Editions Braun, Paris.[23] At that time Braque – 'le patron' – became the model for a humanised modernism as distinct from the austerity of constructive art and the neurotic passion of Picasso. As Germain Bazin wrote, 'In the world in which we live, tormented by so vast an upheaval … the works of Braque afford the most exquisite and soothing means of escape.'[24] Significantly, Patrick Heron was Braque's greatest advocate in Britain, describing him as one of the great figures of modernism and seeing in his painting the completion of the 'surface consciousness' which began with Cézanne.[25] Wynter's work was less obviously a homage than Heron's. Nevertheless, for a time he adopted the Frenchman's style in which figure and ground are united by an almost decorative linearity. Though the Braquean manner was especially evident in a small group of works from 1948, it would recur as late as 1951 in *Cornish Landscape*, Wynter's contribution to the Festival of Britain exhibition *60 Paintings for '51* (fig.26).

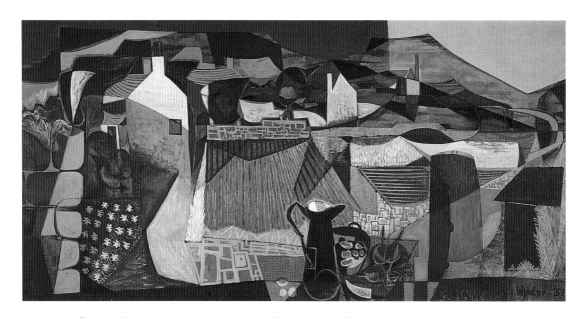

Despite this, he seems to have shown little interest at that time in art on the Continent. In 1949 he visited Paris for the first time with his brother Eric and then travelled alone to Provence. In a letter from Avignon he gave an account of his trip and there is little mention of art: in Paris he visited an Impressionist exhibition and the Louvre, but seems to have been equally impressed with the Eiffel Tower and Josephine Baker at the Folies Bergères, and though he went to Antibes, Vence and St Paul-de-Vence, there is no mention of Picasso or Matisse, then so intimately linked with the area. Similarly, two years later he went to Collioure, but showed no interest in the town's association with Matisse and Braque's Fauve period.[26] In contrast, Wynter did write that in Provence he had 'drawn and drawn and drawn' and was planning a series of Provençal landscapes, enthusing about the countryside and the opulence of its vines, cherries and olives. In fact few such works seem to have come to fruition and his exhibitions in 1950, 1953 and 1955 continued to be dominated by Cornish landscapes and still-lifes drawn from nature. In fact, by the 1950s, though the themes remained the same, the paintings had changed considerably.

The years 1952–6 were another period of uncertainty for him when he experienced great difficulty in painting. In the early 1950s tensions grew in his marriage to Sue Lethbridge and, following the birth of their daughter Rebecca in 1953, she and the children spent an increasing amount of their time in a house that his father had bought in north London; they remained on friendly terms nonetheless. One contributory factor was his teaching at Bath Academy of Art, at Corsham Court in Wiltshire, which became an important site for artistic exchange. The Principal, Clifford Ellis, varied the programme by enlisting working painters and sculptors as lecturers. With William Scott as Head of Painting and Kenneth Armitage Head of Sculpture, several 'St Ives' artists were able to teach there, including Lanyon and Frost. Wynter first taught there in 1951, but employment was neither continuous nor certain.

Away from the politics and claustrophobia of St Ives, of which Wynter often tired, Corsham provided a place for important social and professional interaction and one might associate it with a new formalism in his paintings. Through Scott's influence, the school was associated with a French style of

26
Cornish Landscape
1951
Oil on canvas
122 × 241.5 cm
Collection of The Suter Te Aratoi o Whakatu, Nelson, New Zealand

27
Levant Cliffs 1952
Monotype and gouache on paper
35.5 × 49 cm
Private collection

painterly semi-abstraction. Patrick Heron explained the importance of the retention of figuration to Wynter in May 1951 when he proposed 'The Post-Abstract Group' as 'a counterblast' to the *Abstract Art* exhibition organised by Victor Pasmore. Consisting of Heron, Wynter, Lanyon, Scott, Ivon Hitchens, Keith Vaughan and the sculptor Reg Butler, this group would reassert what Heron described as 'the central tradition of representational art (that is permeated by abstract force but not dominated by it)'.[27] Though the group does not seem to have come together as Heron hoped, the idea reveals an important facet of British art of that period. With the exception of the purely abstract paintings, sculptures and constructions of such artists as Pasmore and Kenneth and Mary Martin, post-war art remained largely figurative.

Heron emphasised his point with the examples of Picasso, Braque, Gris, Matisse and Bonnard, but Wynter was among the British painters whose work increasingly demonstrated a knowledge of younger French artists. Immediately after the war, with the collapse of the intellectual framework for Surrealism and Constructivism and other forms of 'pure' abstraction, there was perceived to be an artistic vacuum. Henry Moore and Giacometti came to dominate sculpture, but in the field of painting Minton's later assertion that 'After Picasso and Matisse there is nothing more to be done' summarised many painters' perception of the situation.[28] It was this apparent lack of progress and direction that facilitated the elevation of those artists whose work developed from Cubism, such as Pignon, and allowed the continued dominance of the canonical figures of modernism: Picasso, Braque and Matisse.

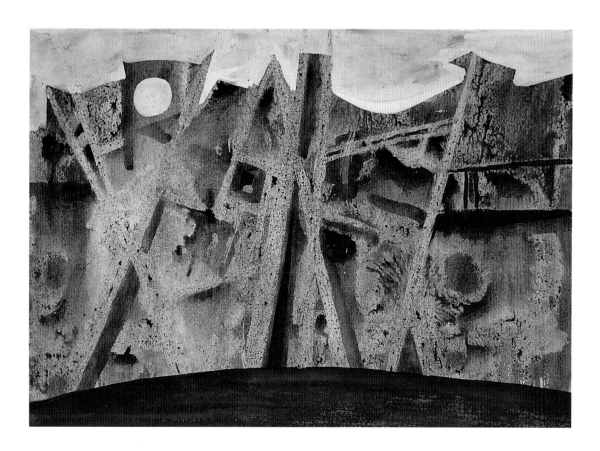

However, an awareness of a new generation of French artists began to emerge. In his review of the 1949 Salon de Mai in Paris Heron singled out for discussion the work of Alfred Manessier and Jean Bazaine and made clear that by that time such artists as Maurice Estève and Pierre Tal Coat were already known to British audiences. Though their styles differed, all of these artists worked in a loose abstract manner and many were collected within the category *Tachisme*, defined by the critic Michel Tapié. This term highlighted the emphasis placed by the artists on the individual brushmark (*tache*) as well as on a coherent overall image. The material of the paintings and the gestural manner of their production were primary and this was especially evident in the work of Pierre Soulages, which was made up of broad strokes of black paint. Soulages showed at the Salon for the first time in 1949 and it is a reflection of changing attitudes that Heron did not mention him in his review, was rather dismissive of him seven months later but, in 1952, considered him the finest among a group of Parisian painters.[29] Similarly lauded was the work of Sam Francis, a Californian artist living in Paris. His paintings consisted of clusters of large strokes of colour on fields of white canvas and were seen to epitomise Abstract Impressionism, a phenomenon so-named because its all-over style and debt to natural sources were seen to synthesise contemporary action painting with the late work of Claude Monet. A shared fascination with natural phenomena, the material of paint and shallow pictorial space enabled the critic Lawrence Alloway to accommodate 'St Ives' artists within this category.[30] Heron and Scott established contact with several of the young French artists and there was considerable exchange between London and Paris, with recent

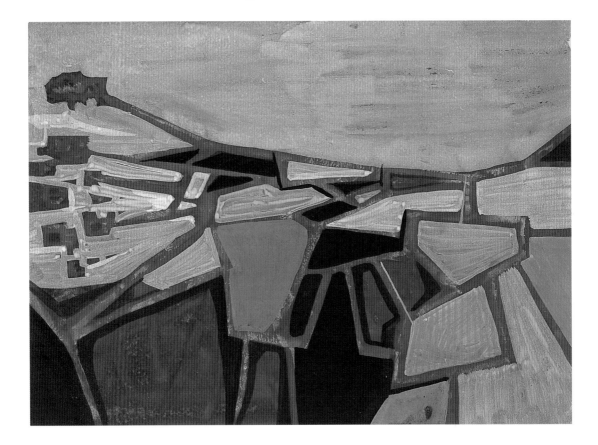

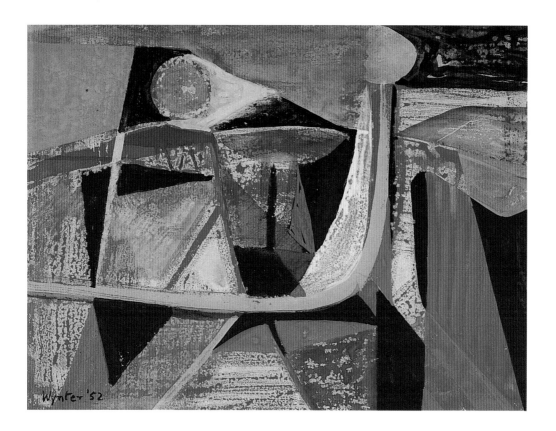

28
*Landscape with Hill
Cultivation* 1952
Gouache on paper
25.4 × 35.6 cm
Private collection

29
Madron 1952
Gouache on paper
22 × 30 cm
Private collection

French art on show at a number of private galleries and at the Institute of Contemporary Arts (ICA). This was augmented by the first-hand experience of post-war Paris of such artists as the Scot William Gear, who produced abstract compositions derived from landscape.

Executed in the light of these new influences, Wynter's gradual change of style was in step with adjustments in the work of many of his contemporaries. Loosely, one might think of this time as a post-Festival period for, just as the 1951 Festival of Britain has been seen to mark a point of transition in British social history, so it coincided with the end of a time of hesitation in British visual culture. As Britain began to emerge from the period of austerity with a reversion to a Tory government and an emergent consumer culture, more rigorous but subjective forms and practices of art took hold. The early 1950s saw a new painterliness enter the work of Lanyon, Scott and Hilton, for example, and a new generation of sculptors – in revolt against the idealism of Moore and Hepworth – emerged under the influence of Giacometti's emaciated figures.

Wynter's style developed only gradually and fitfully. His established manner would persist in isolated pictures until 1956 and a residual Ernstian influence might be identified in such paintings as *Levant Cliffs* 1952 (fig.27). Nevertheless, by 1950 some works showed a new formality as the landscape was reduced to its most basic forms, a feature shared with Alan Reynolds whose paintings enjoyed great popularity around 1954. In particular, the lie of the land – the tautness of the line linking one granite tor and another, for example – and Penwith's network of stone hedges provided a structural framework for what

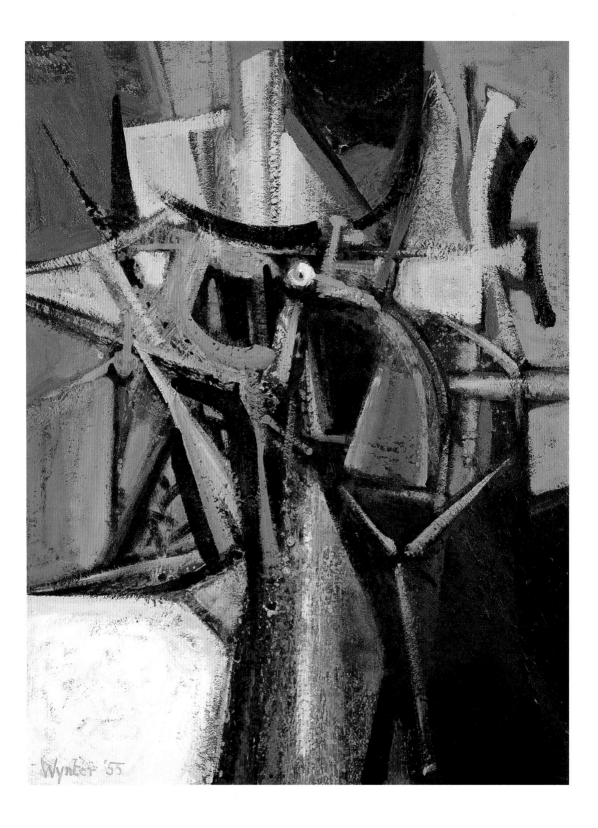

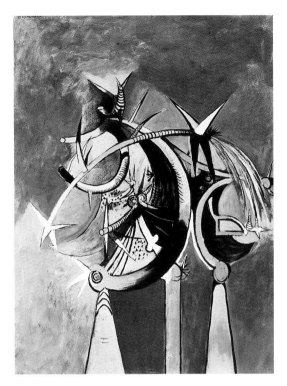

30
Headland 1955
Oil on board
121 × 91.5 cm
Private collection

31
Graham Sutherland,
Thorn Heads 1946
Museum of Modern Art,
New York

were often almost totally abstract works (fig.28).

Though initially formal abstractions from a specific site, Wynter's paintings, echoing contemporary sculpture, can be seen as landscapes of anxiety and in many their edginess was enhanced by their bold colouring. *Madron* 1952 (fig.29) shows how the Braquean order disintegrated into compositional conflicts between straight line, angle and curve that jar as much as the unworldly reds and yellows of the palette, as if the landscape has been transmogrified into the 'abortive geometry' of Bram Van Velde's brightly coloured gouaches.[31] In 1953–5 the connection with representation was stretched further as the structure of the landscape and plant forms coalesced into dramatic and complex interlocking compositions. Recalling Sutherland's thorn paintings (fig.31) and the sculptures produced in their wake by Reg Butler and others, the violence of such pictures as *Headland* 1955 (fig.30) could fit just as well Read's description of an 'iconography of despair, or of defiance … of excoriated flesh, frustrated sex, the geometry of fear'.[32] Such a description seems especially apt for *Offshore Rocks* 1953 (fig.32) in which thin dribbles of paint underlie the dominant structure, alluding perhaps to water running over rocks but suggesting also a certain abject, corporeal fluidity. The runnels up and across, as well as down, the painting recall the style of some of the German Wols's work, which was derived from the observation of the natural environment and was felt to create a sense of instability, to suggest what Sartre called a world in a state of 'transubstantiation permanente'.[33]

The dominance of a structural matrix in *Offshore Rocks* would become a major characteristic of Wynter's painting after 1956 and a similar precursor was seen in *Dark Landscape* 1954 (fig.33). The strong framework reveals his debt to Soulages's use of bold gestures in black and validates Heron's claim that his work 'was totally literate by Paris standards'.[34] It may also be seen to refer to the structures of the landscape and as an allusion to subterranean forces. The purple suggests both night and the heather which envelops the moors at the end of the summer and the black might also be thought to derive from the regular burning of the gorse. Thus the landscape and natural processes were used as the starting point for a work which was perceived in formalistic terms. As such, *Dark Landscape* anticipated the paintings which succeeded a major change in practice in 1956.

In his enthusiastic initial response to the landscape of West Penwith Wynter wrote, 'it seems to me that there are no "views"'.[35] Though always concerned with the land itself, it was only in the 1950s that he began to produce paintings which were totally freed from the conventional view. Like other 'St Ives' artists, he developed an approach that tried to accommodate the landscape's structure and history and to convey a physical as much as visual experience of it.

It was no coincidence that this reformulation of landscape painting came at a time when West Penwith was becoming increasingly perceived through the consuming gaze of the tourist. Just as his life-style refuted domestic modernisation, Wynter's exploration and examination of the moors can be seen as a counter to the materialism of modern life of which tourism's simplistic construction of Cornwall as picturesque was an aspect. However, the relationship between artists' colonies and tourism is a close one and the tourist is similar to the artist in that both are set apart from the indigenous population of a place and both, in their search for the picturesque, structure the landscape to suit their own desires. The popularity of Wynter's early work is witness to this. As well as the landscape on which he drew, one should also see in his painting an increasing defiance of the idea of an art of stability and an emphasis on the creation of a sense of anxiety and disorientation. Both the landscape and this search for impermanence would persist in his later work.

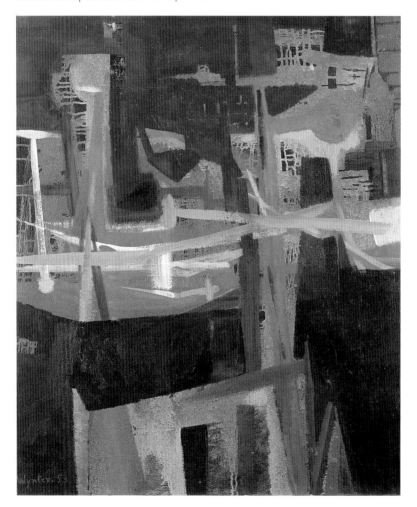

32
Offshore Rocks 1953
Oil on board
72.4 × 61 cm
Government Art Collection

33
Dark Landscape 1954
Oil on board
91.4 × 71.7 cm
Private collection

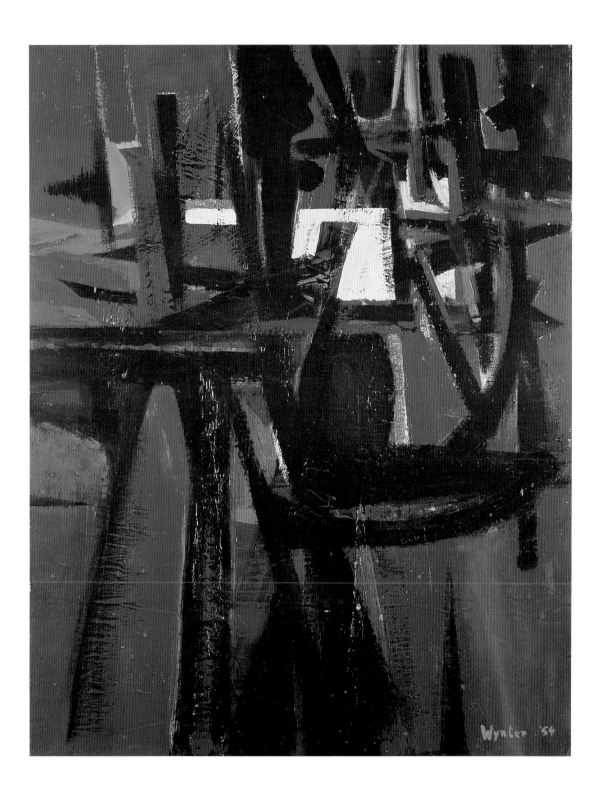

3
Painting and Natural Process

The year 1956 has been singled out as one of radical change for Wynter. At the beginning of the year he was working in a borrowed studio in The Boltons in London's Chelsea. He had been through a fallow period and was reported to have stopped painting completely in 1955,[1] but in London he developed a new manner of working which would prove hugely successful. The breakthrough has been associated with changes in his circumstances: a small inheritance had enabled him to stop teaching (his last session at Corsham was at the end of 1955) and to buy The Carn, and this gave him a sense of freedom and optimism which was fuelled by the stimulus of his period in London. The effect of the change on his productivity is demonstrated by the fact that he completed eleven paintings between February and July.[2] This new confidence was enhanced by his relationship with Monica Harman, whom he had met at Bath Academy of Art. She moved to Zennor later in 1956 and was married to Wynter in March 1959. Two sons were born in The Carn: Tom in 1961 and Billy the following year.

Wynter's new style and method of painting was announced by the first two works produced in London in January 1956: *The Interior* (fig.34) and *Prison*. Made up of a field of abstract marks, they heralded a body of works which displayed a new freedom and scale. Though superficially different, it is striking how this type of picture, which he produced from that time until *c.*1964, was continuous with the concerns that had informed the earlier works. The focus of his attention remained the same but in these later paintings he was, in his own words, 'approaching nature from the other side'.[3] Typically of the period, the works were largely assessed in formal terms, but one can discern a variety of ways in which ideas of nature and the natural helped to determine them. In this they were not unique but part of a wider enlistment of the concept of organicism in aesthetics and artistic practice.

The works are made up of a matrix of interlocking and overlapping brush-marks, some short or calligraphically curled, others long and gestural. In a range of colours and tones, or sometimes monochrome, these coalesce into overlaid patterns to form a varying surface while also creating an illusion of depth. The pictures are in a constant state of assertion and denial: pictorial space is made and then blocked off; one's eye moves across the surface only to be drawn into the picture, it has nowhere to rest. One feels that given time it could be possible to analyse the way the paintings were put togther, mark upon mark, but such attempts are confounded at the first stage. What was thought to be an initial framework turns out to have been painted over earlier marks or staining; what seemed to be a coloured ground is in fact an oil glaze or varnish applied across a section of the almost finished composition. In some the brush-marks are distributed evenly across the surface, others are drawn towards the

34
The Interior 1956
Oil on canvas
127 × 101.6 cm
Private collection

centre or concentrated along a vertical axis. The effect of the brushwork is one of movement: vertically, horizontally, diagonally or, most especially, as an apparent shimmering upon the surface.

Patrick Heron described these paintings as 'grille[s], or network[s] of brush-signs', strung along, 'as though Wynter were looking into a system of hanging, semi-transparent bead-curtains, ranged one behind another'.[4] The term 'brush-signs' is deceptive as the marks do not, in themselves, signify but are parts dependent on the whole for their identity. The description of the works in terms of successive semi-transparent layers reflected Heron's own interests as set out in the exhibition *Space in Colour*, through which he had tried to define a group of British painters whose primary concern was pictorial space.[5] That Heron's account of Wynter's work was for an American audience was significant, as a tension between surface pattern and the illusion of depth was a key component in the formalist aesthetic which he shared with the leading New York critic Clement Greenberg. While Heron proposed that 'the secret of good painting … lies in its adjustment of … the illusion, indeed the sensation,

of depth, and … the physical reality of the picture surface', Greenberg identified the development of an 'all-over' style as the major achievement of Modernism.[6]

A composition in which intermingling successive planes define depth while asserting the flatness of the picture surface derived ultimately from Cubism. Wynter recognised the relationship of his works to Cubist space and asserted that, more than anything, his new paintings were inspired by Braque's *Atelier* paintings of 1949-56 (fig.35). These large canvases in which a bird – perhaps a symbol of the artist – flies through a studio space defined by diaphonous layers of marks were first shown in Paris in February 1950. Heron, who had seen the first three in Braque's studio the year before, described them as 'the greatest achievement in painting since the war'.[7] There are certainly similarities between them and Wynter's new manner, and the title of the first of his abstract paintings, *Interior*, – apparently coined because the image suggested the inside of The Carn – invites such a comparison; Heron even went so far as to identify a vestigial window at the top of the canvas.[8]

The year 1956 can also be seen as a turning point in British culture and one of the reasons for this was the first exhibition in London of work by the American artists who became known as Abstract Expressionists. In January, as Wynter developed his new practice, the exhibition *Modern Art in the United States* at the Tate Gallery introduced a group of painters of whom only Jackson Pollock had been shown in Britain before. Although the radically new approach of the Americans was known through reproductions, the accounts of artists such as

45

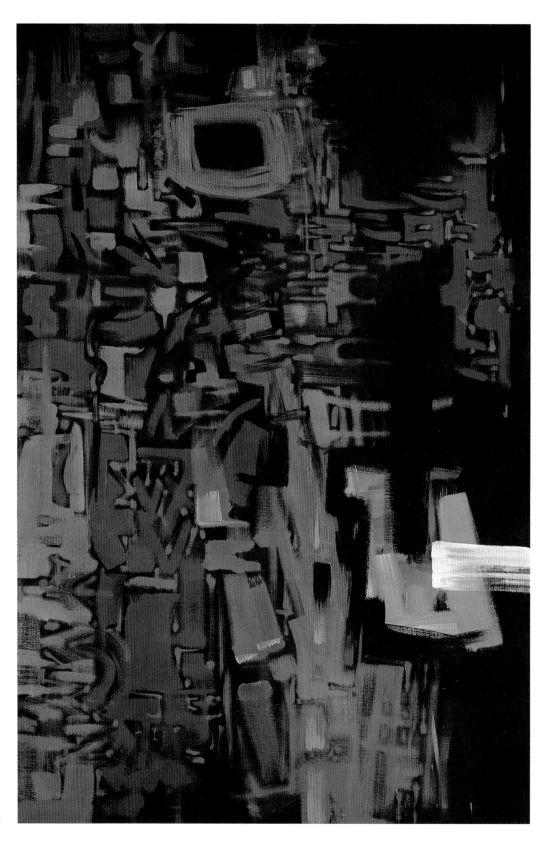

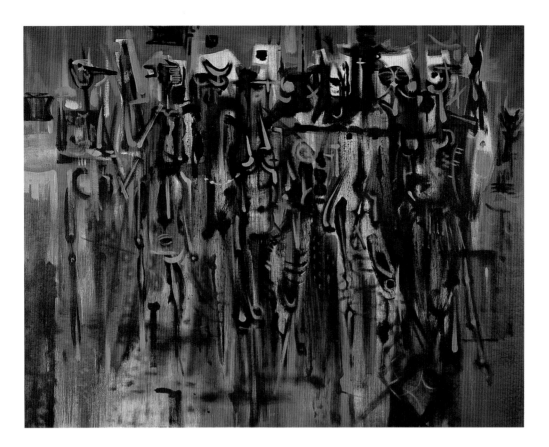

38
Mars Ascends 1956
Oil on canvas
152.4 × 101.6 cm
Tate Gallery

39
Hostile Tribe 1956
Oil on canvas
111.7 × 142.2 cm
Scottish National Gallery of
Modern Art, Edinburgh

William Scott and Alan Davie and, most importantly, the international advocacy of Greenberg, this show opened up in Britain new possibilities for a non-figurative art and for painting on a scale hitherto unknown. In November 1956 Heron acknowledged that Wynter's new paintings 'owe[d] a great deal to the arrival in our English consciousness of American abstract expressionism' and specifically related the 'all-over' style to the work of Mark Tobey (fig.36) (whom Wynter had met in St Ives the year before) and Bradley Walker Tomlin.[9] Both worked in a style characterised by a pattern of calligraphic marks, though Tobey's 'white writing' (developed at Dartington Hall in Devon in the 1930s), to which Wynter's work is most often compared, is small in scale. Heron argued that 'Wynter's art has, by comparison, a much wider range: it is plastically more complex and profound than Tobey's, and Wynter is a more powerful colorist.'[10]

The Americans with whom Wynter was linked were seen to be concerned with ideas of spiritualism, ritual and vitalism. As well as tracing formal genealogies, it is important to consider how and why such a common form of expression developed at that time in Britain, America and Europe. Regardless of stylistic influence, the similarity of these painters' work is attributable to a shared set of references and practices which were, in their turn, determined by desires within common cultural and historical circumstances. The artists were interested in spirituality and psychoanalysis, and this influenced their practice and so affected the appearance of the paintings that they produced. In particular, their works reflected the emphasis placed upon the artist's own subjectivity and the unconscious development of the work of art. From 1956, the various issues with which Wynter had previously engaged came

47

together in his studio practice, the resultant images and their underlying theory and intention.

That Wynter's paintings are, in some way, related to the natural world is signalled by their titles, which, despite the artist's insistence that they were coined after completion, are necessarily part of the works' signification. Many allude to a particular location or set of conditions, *High Country* 1956 (fig.37), for example; others to natural phenomena, such as *Seedtime* 1958–9 (fig.43) and *Mars Ascends* 1956 (fig.38); and a few, like *Hostile Tribe* 1956 (fig.39), to an imaginary primitive history. Several refer to water and its behaviour, *Riverbed* 1959 (fig.47), for instance, and this was to become a dominant theme of later paintings. The journey was a recurring idea, as signalled by *Saga I* 1960 (fig.40), and some works are even concerned with the city. The relationship between the paintings and external sources operated at the physical

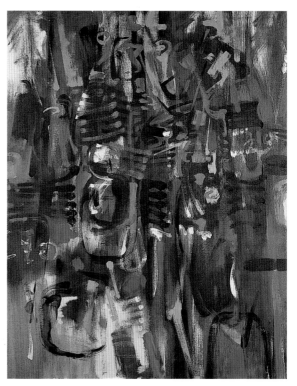

level also. Wynter's interest in nature was expressed primarily through physical participation – walking, climbing, swimming and canoeing – and his own body is similarly at the centre of the paintings. Their form and format were determined by the artist's physical being: often six feet by three, their size may be seen to equate with that of the figure and the pattern of marks reflects the limits of his body and its movements. Such an association may accord with subjective interpretations invited by the names of the first two: *The Interior* 1956 (fig.34) and *Prison* 1956. Though the titles were said to be determined by the paintings' form, they nonetheless open up potential psychological readings and Wynter's later reliance upon more objective labels might reflect a desire to obscure that aspect.

The major departure in the new works was the fact that nature came to operate at the level of the paintings' making; the compositions were built up in a manner that aped natural processes of development and sedimentation. The works would 'grow' organically in as much as each mark was made in response to its predecessor and each, in turn, demanded a further response. The artist wrote in 1957:

Obviously it is I who have put into them what they contain but I have done so with as little conscious interference as possible, allowing them at every stage in their growth to dictate their own necessities.[11]

Such an organicism was increasingly evident in artistic production at that time, especially amongst artists associated with the Institute of Contemporary Arts, such as Richard Hamilton, and with the teaching regime of Basic Design, which was pioneered by Harry Thubron and Victor Pasmore. Both these groups, and several artists in St Ives, adopted a painting practice in which the forms and compositions of their works developed in a way modelled on theories of natural

growth. This was influenced by the biologist D'Arcy Wentworth Thompson, who proposed in his book *On Growth and Form* that the morphology of all living organisms was determined by the forces of natural growth and was summarised in the description of organic form as 'a diagram of forces'.[12] The idea was taken up by several figures – most importantly Herbert Read – as a principle for art and for much else.

The title of Read's *Grass Roots of Art* (1947) signalled his association with the post-war desire for a more human and rooted creativity and in it he posited nature – understood as 'the measurements and physical behaviour of matter in any process of growth and transformation' – as the basic criterion for art.[13] He even extended the organic principle to social theory, arguing that 'the ideal condition of society is the same as the ideal condition of any living body – a state of dynamic tension [for] … only in that way can society be stirred into the vibrations and emanations of organic growth'.[14] Read was one of a range of figures interested in organic aesthetics and this discourse was marked by a symposium at the ICA. The subsequent publication's editor, Lancelot Law Whyte, advocated an aesthetics based on Gestalt theory – the idea that elements go to form an ensemble greater than the sum of its individual parts.[15] This could clearly be applied to Wynter's paintings, in which individual brush-strokes are both distinct and necessary parts of a larger, coherent image. Even more pertinent were the theories of Rudolf Arnheim, whose *Art and Visual Perception* Wynter was quick to buy when it was published in 1956. In the symposium Arnheim argued for a definition of objects 'as processes that have been temporarily arrested on their way to final equilibrium'.[16] One might associate such an understanding of art with Wynter's production of paintings in which the composition has not only 'grown' organically but seems to continue to change as one looks at it. In 1957 he explained what he hoped to achieve:

I think of my paintings as … something that generates imagery rather than contains it. … One should be able, ideally, to make paintings which throw off imagery of different kinds at different times to different people, continually unfolding different aspects of themselves, ambiguous and paradoxical paintings with no main 'theme', from which the spectator may, by participation, extract his own images.[17]

The idea of a painting in a constant state of change recalls Henri Bergson's theory of 'duration', which proposed an understanding of time as a constant flux rather than a series of static moments, a constant state of becoming rather than being.[18] Bergson's philosophy had been an important source for the Cubists and went through a revival after the Second World War; specifically, through the advocacy of the potter James Tower, he was the subject of particular interest amongst the staff at Corsham in the early 1950s.[19]

Bergson also discussed the way in which 'successive perceptions' might be said to coalesce in one's memory.[20] Since the war Wynter had read the work of another writer who extrapolated these ideas to encompass a more speculative field. J.W. Dunne proposed a model of the universe as strung out in time as it was in space so that any moment, past or future, could be accessed by the mind, normally in the unconscious – hence prophetic dreams.[21] There is a connection here with Jung's 'collective unconscious' and one might see the idea of time as a state of interminable fluidity reflected in the conception of Wynter's paintings as containers of a diversity of associations.

The unconscious mind was the key to these associations and Wynter explained his approach in terms of a 'discipline', opposed to 'conscious

method … learned, mastered [and] perfected', which had to be 'renewed at every moment to fox the intention'.[22] The centrality of the unconscious was re-flected in his stated desire to separate vision from cognition. 'I find it helpful', he wrote,

to think of the moment at which the eye looks out at the world it has not yet recognised, in which true seeing has not yet been translated into the useful concepts with which the mind immediately swamps it. This moment of seeing is in fact a fragment of a continuous process … a kind of 'substance' from which we construct our world of human experience. I think of myself as embodying this 'substance' in paint.[23]

The spontaneous organic development of the paintings reflected this ambi-tion, for Wynter believed that 'drawing organises your looking' and, but for specific exceptions, did not make drawings from 1956 until the late 1960s.[24] He saw the paintings as determined by nature operating through the unconscious. As part of his attempt to escape his own consciousness, he adopted another variation on Max Ernst's chance techniques and constructed a drawing machine. Wynter swung a pen on a wire over a sheet of paper underneath which were four magnets, and its almost random trajectory was determined by the magnetic fields' effect on the wire. The results do not seem to have directly contributed to the paintings (though the device anticipated his kinetic work of the 1960s), but he did experiment with a variety of means of suppressing the ego and so accessing the unconscious.

Most of the mystical and spiritual texts which Wynter read, such as the *Tao Te Ching*, contained the idea of exceeding one's individual conscious will. One of the key works for him, as for several other artists, was Eugen Herrigel's *Zen in the Art of Archery* (1953). There he read that 'If one really wants to become a master of an art … one has to transcend technique so that art becomes an "artless art" growing out of the Unconscious', one's proper condi-tion being 'realized only when completely empty and rid of the self'.[25] In this 'egoless' state the Zen archer becomes one with the target and the arrow leaves the bow with no effort or conscious thought but through natural necessity; its release is compared to the bending of a snow-laden branch to save itself from breaking. It is unlikely that Wynter actually tried to paint in such a state, but his interest in it reveals an important aspect of his intention. It is at this point, perhaps, that he comes closest to Tobey, whose working practices and imagery were similarly influenced by eastern ideas of selflessness.

A rather different strategy for achieving such a suppression of the cognitive self was Wynter's use of the drug mescaline. Other drugs, specifically Benzadrine (a legal amphetamine), had been used freely by the circles in which he moved in Cornwall and Soho and the British Surrealists had experi-mented with mescaline before the war. However, it achieved wider publicity when Aldous Huxley discussed his experience of the drug in *The Doors of Perception* in 1954. The psychic Rosalind Heywood advertised for an artist interested in experimenting with the drug and Wynter did so in July 1954. From then on, until its legal control in 1960, he took it with some regularity and enthusiasm, encouraging friends to join him and drawing profusely while under its influence. Though he didn't actually paint on such occasions, the drawings reveal a preoccupation with expressing the artist's state of mind through self-portraiture (fig.41) and a conscious study of visually disturbing or ambiguous objects, such as a mobile in front of a mirror or a reflection in a window. The link between the drawings and his paintings is rather tenuous, but certain qualities in the paintings do accord with descriptions of mescaline's effects. Users tell of

41
Untitled c.1955–60
Charcoal on paper
53.5 × 42 cm
Private collection

how a surface seems to separate into a series of shimmering layers, and one may also relate a work such as *The Indias* 1956 (fig.42) to the drug's reported enhancement of colours that gives them a jewel-like intensity. In an embittered account of his experiences with the drug, the French artist Henri Michaux described a discoordination of his writing which can be related to the formal fracturing in Wynter's paintings.[26]

Wynter's brother said that mescaline 'strips the eyes for vision' and Huxley saw in this heightened perception a means of spiritual enlightenment.[27] When on the drug, flowers became to him,

> nothing more and nothing less, than what they were – a transcience that was yet eternal life, a perpetual perishing that was at the same time pure Being, a bundle of minute unique particles in which ... was to be seen the divine source of all existence.[28]

With mescaline you could achieve the Romantic ideal and 'see the World in a grain of sand', but the likely purpose of the drug for Wynter was as a strategy to suppress the will. It was a means, to quote Huxley again, of becoming 'the blessed Not-I released for a moment from my throttling embrace', and of

42
The Indias 1956
Oil on canvas
228.6 × 111.7 cm
Private collection

43
Seedtime 1958–9
Oil on canvas
142.2 × 111.7 cm
Tate Gallery

achieving non-cognitive vision – to see 'what Adam had seen on the morning of his creation – the miracle, moment by moment, of naked existence'.[29]

So Wynter employed a number of means of suppressing the ego in order to paint from his own sub-conscious and, implicitly, to access a collective unconscious. In this one must draw parallels with artists such as Jackson Pollock, whose apparently 'automatist' techniques were also based on an engagement with Jungian analytic psychology, and in Britain with Alan Davie whom Wynter knew. In the organic theory underlying their production and aesthetic analysis, Wynter's pictures might be seen to re-establish what Jung called 'the continuity of nature', a concept in which mankind was reunited with the 'natural' world. This is most clearly signalled by their references to natural rhythms, such as the seasons and, most particularly, the tides and the moon that governs them. As with Pollock, the moon had been a recurring motif in Wynter's work from the late 1940s onwards and may equally reflect the influence of *The White Goddess*, in which Robert Graves associated poetic myth with the Moon-goddess and argued that 'The Theme' of great poetry was 'the antique story ... of the birth, life, death and resurrection of the God of the Waxing Year'.[30]

44
Kayak 1961
Oil on canvas
122 × 152.4 cm
British Council Collection

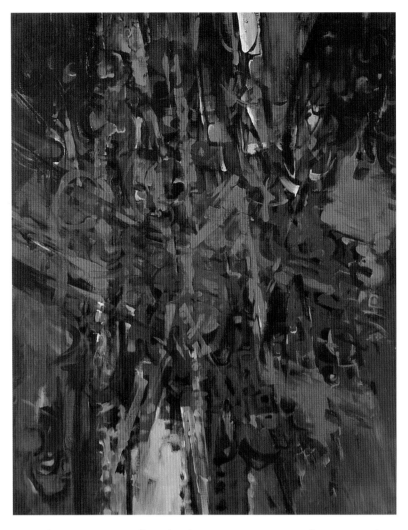

Thus *Seedtime* 1958–9 (fig.43) takes on a certain significance, as does the *Firestreak* series (fig.45), which derived from the seasonal burning of the moorland gorse. This procedure, which more than once almost destroyed Wynter's home, is necessary to refresh the soil for new growth and thus provided a potent symbol of danger, destruction and renewal.

In the artist's view his paintings of the early 1960s differed from those of the late 1950s. The forms were generally larger and there was less emphasis on visual flux. He acknowledged their relationship with landscape:

I used to be a landscape painter. Am I still influenced by landscape?

The landscape I live among is bare of houses, trees, people; is dominated by winds, by swift changes of weather, by the moods of the sea; sometimes it is devastated and blackened by fire. These elemental forces enter the paintings and lend their qualities without becoming motifs.[31]

This echoing of natural processes was evident in the *Sandspoor* series (fig.46), which was based on the idea that sand bears witness to the natural processes which have shaped it. That structures in the desert or sand dunes on the beach have been carved by the wind or by water is consistent with the

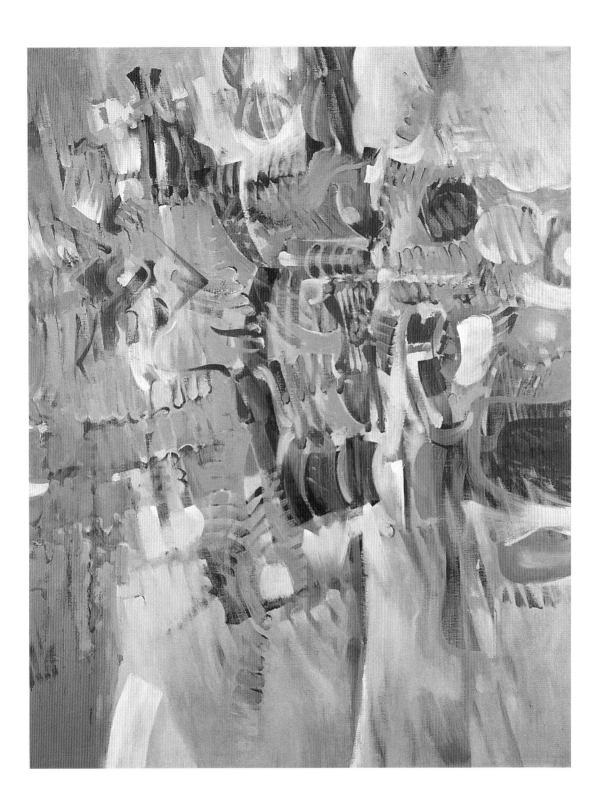

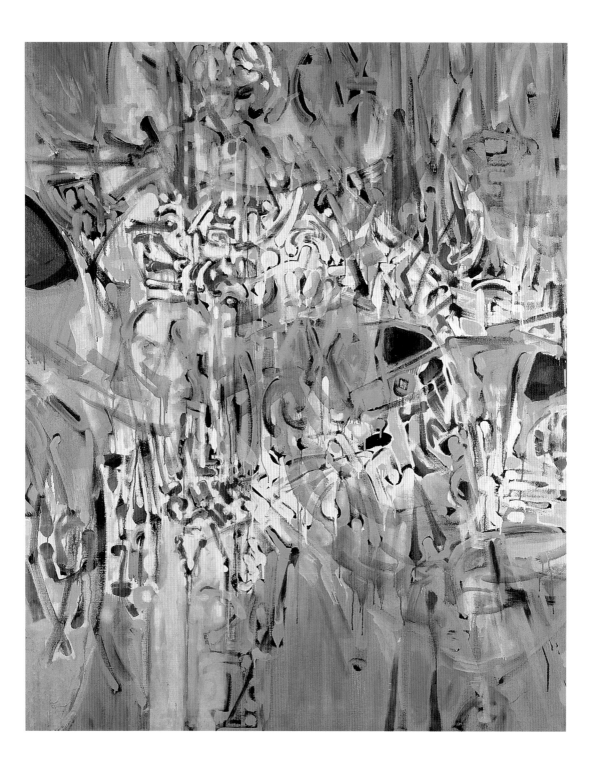

understanding of landscape as a record of its own history and reminiscent of Thompson's theory of growth and form. In 1960 Wynter explicitly compared a similar natural process – the flow of water – to his painting practice:

A stream finds its way over rocks. The force of the stream and the quality of the rocks determine the stream's bed. This in turn modifies the course of the stream, channelling out new sluices and hollows. The stream erodes the rock, the rock deflects the stream, until, at some high point, the stream bursts its banks and falls into a ravine. The dry stream bed, carved and hollowed, remains. Its form contains its history.

There are no rocks or streams in my paintings but a comparable process of dynamic versus static elements has attended their development and brought about their final form.[32]

In such paintings as *Riverbed* 1959 (fig.47) Wynter mimicked the behaviour of water with brushstrokes, which he discussed as 'streams' entering the canvas, encountering other streams and creating 'turbulence'.[33] For years he had examined the traces of the past in the landscape – lost streams and tracks – and the paintings also allude to a human presence in, and recorded on, the land. The artist explained that *Sandspoor* was 'a generic title of a series partly descriptive (traces left by water, wind, etc. on sand), but mainly concerned with the spoor as a record of an action'. He cited as a source of inspiration a passage from Wilfred Thesiger's *Arabian Sands* in which a Bedouin,

having examined tracks in the desert is able to say correctly 'they were Awamir. There were six of them. They have raided Januba on the southern coast and taken three of their camels. They have come here from Sahma and watered at Mughsin. They passed here ten days ago.'[34]

The concept of the landscape as a bearer of memory, a record of its own past, is registered in the paintings' structure of superimposed layers which mimic the results of natural processes and the deposition of past occupations.

There is a further echo of nature in the painting process which one might see as the recording on the canvas of the artist's presence in the work. This is not simply the inescapable expression of his unconscious self, but the suggestion, through the predominance of human-scale pictures and the range and distribution of the brushmarks, of the artist's physical relationship with the painting. Wynter has been described as 'someone who was very much "inside his body"', and his bodily involvement in painting is reflected in the resulting works.[35] Many are tall and thin with small marks clustered around the middle in contrast to the long strokes towards the bottom, reflecting the movement and reach of his arm. This relationship between the work and the physical presence of the artist enhances the concept of the paintings as records of their making and echoes the perception of the landscape as a palimpsest. When first in Cornwall, Wynter told Heddi Hoffmann with excitement how he had come across a rock inscribed 'WHHUDSONOFTENCAMEHERE';[36] just as Hudson and Thesiger's Awamir left their mark upon the land, so the paintings register Wynter's own passage across the canvas and, through organic process, suggest a parallel between artistic practice and landscape.

47
Riverbed 1959
Oil on canvas
152.4 × 122 cm
Private collection

48 overleaf
Bryan Wynter painting
in 1959

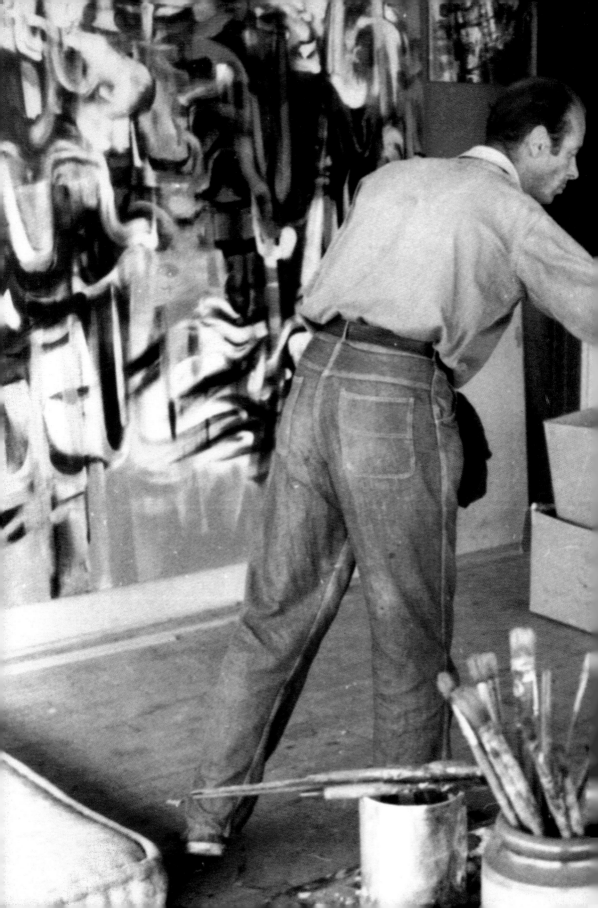

4
Movement in Space and Water

For some years Bryan Wynter had the parabolic reflector from a Second World War searchlight in the corner of his studio. In 1960, in a symbolic negation of its violent associations, he incorporated it into a work of art, suspending painted pieces of card in front of it and setting the whole ensemble within a white cube with one open face. The cards hung on wires on which a rotating magnet, located above the box, exerted a force, making the suspended elements turn in an almost random pattern. A light hidden in the black-painted interior of the box illuminated the pieces and later its heat was used to provide a quieter impetus to the mobile's movement than the original motor. As they spun, the pattern of the cards was reflected by the concave mirror, so that the inverted coloured forms interpenetrated, multiplied, distorted, disappeared and seemed to loom from the box into the room. Occasionally, the cards would separate to reveal the viewer's own image, establishing a dialogue (figs.49 and 50).

Wynter produced six such works in the following five years and they were exhibited at the Waddington Galleries in July 1965. At the last minute he named them IMOOS – an acronym for Images Moving Out Onto Space – 'in default of any other more ordinary satisfactory names'.[1] He explained that he had made each distinct from the others in order to 'explore different approaches' and gave a brief account of his working methods:

The elements were planned, cut out, painted, reversed & juxtaposed all together on the drawing board. They were then set free to move before the reflector. However carefully each work was planned there were always unexpected 'free' developments.[2]

The notion of the liberation of the cardboard elements gives an indication of how he viewed the role of chance in the works.

The exhibition of IMOOS was a success, the purchase of several by public collections giving an indication of their perceived importance. They were said to be the 'hit' of the 1967 Edinburgh Festival[3] and, that year, Wynter produced a new one (abbreviated to *IM VII*) for the Hayward Gallery's *Kinetics* survey. In 1970 a huge mobile, six feet high, was commissioned by a Dallas advertising company to hang at the end of a corridor. The following year Leslie Waddington commissioned a further set, but when these were shown in October 1974, shortly before the artist's death, they were largely ignored by the critics and none was sold. Wynter had anticipated this and 'felt a conflict' between his desire to paint and an obligation 'to produce a series of mobiles which for him had come to the end of their creative possibilities'.[4]

Wynter talked of the IMOOS as continuous with the paintings he had been making since 1956, in which, despite the persistent theme of nature, his primary declared interest had been in the visual effect, the relationship between the object and the spectator. To understand the IMOOS one must recognise that

49
IM VII c.1967
Gouache on card, wire, mirror and light set within a poainted wood box
101.5 × 97.8 × 108.6 cm
Bristol City Art Gallery

50
Second view of *IM VII*

they were not a departure from painting but a development of it and it is significant that the artist continued to paint whilst producing them. They developed the spatial ambiguity that had characterised the earliest of his non-figurative paintings and he described the first (fig.51) as 'stylistically a salute to Cubism ... the Cubist sculptors rendered the style in terms of volume not, as here, in terms of space so that I found myself, in a sense, filling an historical gap'.[5]

Heron, too, noted the continuity, describing the mobiles as extensions of Wynter's interest in pictorial space: their very *raison d'être* was the making visible of spatial depth in terms of colour.[6] In their use of actual movement, the IMOOS may be seen, as they were at the time, as part of a wider Kinetic Art that became prominent in the early 1960s. In addition, they are not only continuous with the artist's own painted works but also with critical issues around modernist painting in general. Indeed, later discussions of Kinetic Art expanded its definition to include paintings, in particular the work of those artists grouped together under the term Op Art.

The constant change of the IMOOS continued the search for visual flux that characterised Wynter's paintings and it is this which unites both kinds of work within a common concern with opticality – the primacy of the spectator's visual perception of the art object. At the end of the 1950s and in the 1960s 'opticality' became a key term in theories of modernism, having been prioritised by Clement Greenberg and promoted, most notably, by his follower Michael Fried. Arguing for flatness as its aim, Greenberg proposed that Modernist painting was purely optical in that it created an illusionistic space only accessible to the eye. The suggestion that, despite the abandoning of perspective, painting cannot but create a visual illusion of depth may be seen as close to Heron's commitment to shallow pictorial space. Fried's application of Greenberg's concept to the work of Jackson Pollock suggests a way in which we might consider Wynter's paintings. He described how the dripped lines unite the picture surface 'to create an opulent and ... homogeneous visual fabric which both invites the act of seeing and yet gives the eye nowhere to rest'.[7] The phenomenon of this visual flux, in Wynter as in Pollock, makes the spectator an active participant in the painting and it is this quality that unites such works with those in which actual physical movement occurs.

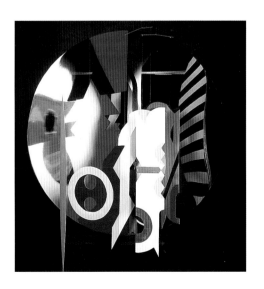
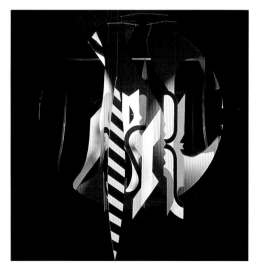

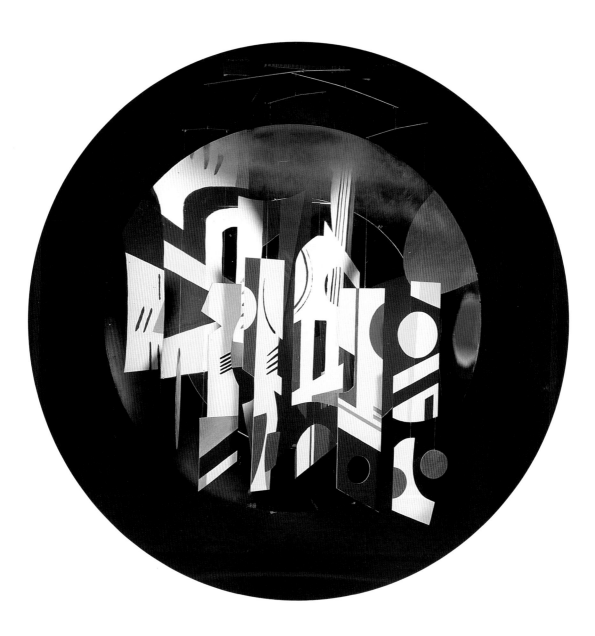

Kinetic Art had a long genealogy and Wynter took some inspiration from the mobiles of Alexander Calder. In Britain this type of art had regained currency during the 1950s in the work of artists such as Lynn Chadwick and Kenneth Martin, but in the 1960s a kinetic art was constituted that far exceeded the mechanised descendants from constructivist roots, incorporating new forms of painting and a variety of light-based works. An early precedent for the latter lay in the work of László Moholy-Nagy, whose *Light–Space Modulator* 1923–30 used moving parts to create varying patterns of projected light. The work appeared in his book, *The New Vision* (1928), the continued pertinence of which was demonstrated by its republication in 1961; Wynter had a copy of that edition.

Vision was central to Kinetic Art, as it was not simply movement within the object that was sought but the creation of that sensation within the spectator –

a 'virtual movement'.[8] It was this which enabled Kinetic and Op Art to be elided. Wynter emphasised the IMOOS's optically disturbing effect, explaining that he had aimed for 'a slow metamorphosis rather than movement', and so their link to Kinetic and Op Art was through a common opticality that disorientated the spectator. In 1960, in the *Situation* exhibition, a group of younger British painters presented large flat canvases which, by undermining the spectator's ability to 'optically locate all the forms in a final spatial order', created a state of 'perceptual instability'.[9] Seen as continuous with that was the work of Bridget Riley, the black and white patterning of which defied the mind's will to order and created a sense of physical imbalance. In defiance of the drive of painting of the 1950s towards an organic whole, the fragmentation of Op Art disturbed the spectators' feeling of physical stability and implicity and, in consequence, their sense of identity.

Distorting mirrors, such as those in the IMOOS, were an established symbol of unstable subjectivity and Wynter sought to maximise their effect. Hung in a certain position in relation to the reflector, the pieces of card in the IMOOS can appear to project outwards. The artist initially tried to avoid this phenomenon, to 'preserve the identity of object and image', but finally chose to capitalise on it by positioning the pieces so they would 'zoom' out and disturb the spatial division between the object and the viewer. He discussed the effect in painterly terms:

space and location became separated & the figure-ground experience could no longer apply. The figure which 'zoomed' toward the spectator dissolved in coloured space to become a ground for elements behind it. Habit & expectation are disarmed & the eye gives up trying to make sense of the situation & accepts it on a level of pure experience.[10]

51
IMOOS I 1960-5
Gouache on card, wire, mirror and light set within a painted wood box
116.8 × 100.3 × 109.2 cm
Whitworth Art Gallery, Manchester

The IMOOS thus progressed Wynter's desire for an art that generated images, and this, combined with their destabilising effect, may be linked to his use of mescaline. It is certainly more than coincidental that a film of the IMOOS, shown on a big screen,[11] resembled the light projections of such artists as Mark Boyle that extended the parameters of Kinetic Art. In the later 1960s these straddled fine art and popular culture and were especially associated with Psychedelia, a sub-culture centred on the use of LSD, an artificially produced variation of mescaline. The visual disturbance of such works as the IMOOS and the effects of psychedelic drugs both contributed to a common pursuit for altered states of being, for experience liberated from material reality.

Wynter had been interested in optics and light for some years. Even before the visual flux of the 'bead-curtain' paintings he had experimented with polaroids. He discovered that cellophane seen through a polarising sheet appeared to change colour when the sheet was rotated through forty-five degrees and, further, that additional layers of cellophane altered the colour to which it changed. Through folding or scrunching the cellophane, one could thus create elaborate and changing visual effects. When he made this break-through is not clear, but it was before July 1956 when Sven Berlin wrote: 'How is the work going, Bryan? I have often thought of your discovery and wondered if you are planning an exhibition of POLEROIDS [sic.].'[12] Wynter tried to develop a means of presenting his discovery as a work of art in which colours would change by natural laws rather than the artist's intervention, but never resolved the problem and his research was superseded by the advent of the IMOOS. Coincidentally, exactly the same phenomenon would be used by the Parisian artist Andrée Dantu some years later, when she projected polarised light through cellophane strips of different thicknesses.

Despite the development of the IMOOS, Wynter never abandoned painting and the second phase of his 'bead-curtain' period ran in parallel with the kinetic pieces. The individual forms within these became increasingly large until, with a work such as *Black and White* 1964 (fig.52), the sense of surface flux almost disappeared. At the same time the artist became increasingly focussed on those works concerned with natural process and the movement of water. From around 1965 Wynter produced a new group of paintings mimicking the behaviour of water (fig.53). In theory there is little difference between these and earlier works such as *Riverbed* 1959 (fig.47), and their form recalls Wynter's 1962 description of his painting process in terms of 'a stream' of brushmarks entering the canvas.[13] However, the matrix of calligraphic elements and glazes gives way to a flatter, more hard-edged and linear pattern which has a more mimetic relationship to its source material. The flowing lines seem to encounter each other causing reflection and refraction, clusters of them intermingling in imitation of streams of water. The movement is more gentle and directional than in the earlier works and this has been explained by the shift of the artist's attention from the rush of tidal water through rocks to currents flowing over

54
Fuente De 1969
Oil on canvas
182.8 × 142.2 cm
Private collection

55
Saja 1969
Oil on canvas
213.3 × 167.6 cm
Tate Gallery

each other.[14] Heron saw the new forms in relation to the painted elements of the IMOOS, but recognised a continuity with the earlier paintings in 'their evocation of a *deep* space; their *movement*; their continuing domination by what one might call those *rhythms of allover fluidity*'.[15]

Wynter had always been obsessed with water and since first settling in Cornwall he had dived and canoed along the coast. In the early 1950s he had made a glass-bottomed boat so that he could study the life beneath the water's surface, and later he acquired a whitewater kayak. His heart attack in 1961 and move from the moors in 1964 to Treverven, near St Buryan, between Penzance and Land's End, also encouraged inland canoeing and holidays tended to centre around rivers in Britain and Ireland. A trip to the north of Spain in 1969 was especially inspirational, and the Rivers Deva and Saja and such local places as Fuente De provided titles for

56
No.8 c.1972
Pentel on paper
53.3 × 42 cm
Private collection

57
Spate III 1965
Acrylic on canvas
152.5 × 122 cm
Government Art Collection

paintings (figs.54 and 55). Wynter was a keen photographer and took many colour slides of natural details which fed into his work: rivulets of water passing over sand, rocks on dried river beds, the broken ice on a roadside puddle. These show that, as well as natural processes, the preoccupation with the superimposition of semi-transparent layers persisted. In addition, many of the water paintings were formulated through Pentel fibre-tipped pen drawings (fig.56), the compositional logic and dynamic of which Wynter would progress using a light box so that patterns could be reused and developed. In this way the forms were repeated and layered in imitation, perhaps, of waves in water.

Made over a ten-year period, the water-based paintings took a variety of forms and were often produced in series, suggesting perhaps an association with different natural phenomena. Some of the earliest were entitled *Spate* (fig.57) and seem to imitate the influx of a stream into a larger body of water. This was developed in a large group with the theme of *Confluence* (fig.58), in which arrangements of lines intersect in manners consistent with the behaviour of water. Later, the patterns were less literal and the use of the meander in such paintings as *Red and Black Streams* 1973 (fig.59) could be seen to reflect the way water adopted certain forms on different scales – the intersection of streams or the carving of the land by a river. This later group often seems more static, the aqueous morphology providing a basis for a more formal abstraction. The artist's increasing use of bold colour – frequently consistent with psychedelic culture – often heightened this aspect, negating the association with water in its intensity and distinctiveness from nature. In many of these works, then, there was a tension between their function as abstract paintings and as formal arrangements derived from and related to water's behaviour in nature. This was also true of a small group of works on

58
Green Confluence
1974
Oil on canvas
182.8 × 122 cm
Tate Gallery

59
*Red and Black
Streams* 1973
Oil on canvas
182.8 × 274.8 cm
Private collection

which Wynter was working when he died on 11 February 1975. Though these signalled another stylistic departure and were larger and flatter, aqueous forms continued to provide their basic vocabulary.

The later paintings were continuous with the earlier work in that they continued to reveal Wynter's fascination with the tension between the permanent and the impermanent – water against granite, for instance – and the permanence of continual change. In a 1969 interview he described his sources – the standing wave, the eddy, the meander – as water's 'archetypal forms'.[16] The concept of archetypes inevitably invoked Jung's theories but, in this context, it also related to a book, in Wynter's possession, on the significance of the behaviour of water. Theodor Schwenk's *Sensitive Chaos*, published by the Rudolf Steiner Press, identified similar 'archetypal movements in water' – the vortex, the wave, the meander – and argued that a return to man's lost relationship with water would lead to spiritual renewal. In an echo of Graves's *The White Goddess* as well as Jung, the author proposed that through a re-engagement with water modern man might re-establish his place in nature. He cited the Romantics' view of it as 'the bearer of the living formative processes … the universal element not yet solidified … unformed, indeterminate … ready to receive definite form … the "sensitive chaos"'.[17]

Water, then, was naturally in the state of flux which Wynter had sought for his art. Schwenk went on to argue that, through tides and its association with the moon and the stars, water may be seen as a 'mediator between earth and the cosmos', becoming 'an image of the stream of life itself'. What's more,

Not only does water give to the human being and to all living nature the basis for existence … but it pictures – as though in a great parable – higher qualities of man's development … such as the overcoming of rigidity in thought, of prejudice … the ability to enter into all things

… and to create out of polarities a higher unity; all these … represent ways in which man may win through to selflessness … just as water aids him in his entry into the earthly world … so it can also lead him to a rebirth of his spiritual nature.[18]

Once again, then, a motif from the natural world is shown to embody a spiritual significance and to provide a means of reforging humankind's link with nature.

A spiritual and existential sub-text may be seen behind Wynter's last paintings, and we can thus identify a concept of nature as a means of individual and social renewal as a trajectory running throughout his work. Though this aspect had been formulated in the traumatic period after the war, its continued relevance was indicated by its proximity to the ideas behind the Whole Earth movement in the late 1960s and early 1970s, which was concerned with individual development and environmentalism. Nevertheless, following Wynter's death in 1975, his friend Patrick Heron railed against a decade of declining interest in his work, and the critical neglect he suffered was an indication of how art appeared to have moved on.[19] While some of Wynter's associates enjoyed continued success, the fading of his public profile followed the decline of interest in 'St Ives' as a collective phenomenon. The proliferation and diversification of artistic production from the late 1950s onwards ensured its obsolescence, just as the simple life-style which Wynter exemplified was overshadowed by the technologically fuelled consumer boom of the 1960s. His work with kinetics had offered a means of exceeding the bounds of what was seen as a 'St Ives' aesthetic, but he had chosen not to develop that strand. Perhaps the refusal to continue his challenge to the conventions of the art object at a moment when such transgressions were an index of artists' avant-garde ambitions fixed him to an earlier historical moment.

A nostalgia for humanist and communitarian values helped in the recupera-tion of 'St Ives' during the 1980s. That recovery was undermined, however, by the simplistic association of the art with a landscape tradition. As well as presenting the work of Bryan Wynter, it is hoped that this account will con-tribute to histories of British art by suggesting that 'St Ives' artists used natural sources for a variety of historically pertinent ends. In Wynter's art it is possible to see a complex understanding of nature operating as a means of addressing the problems of personal and social relations and the questions of existence. The result was, in Heron's words, an art 'characterised by the brilliant, searching, restless, inventive intelligence of one of the loneliest and individual talents of our time'.[20]

60
Red River 1974
Oil on canvas
182.8 × 122 cm
Private collection

Dear Bryan Wynter

by W.S. Graham

1
This is only a note
To say how sorry I am
You died. You will realise
What a position it puts
Me in. I couldn't really
Have died for you if so
I were inclined. The carn
Foxglove here on the wall
Outside your first house
Leans with me standing
In the Zennor wind.

Anyhow how are things?
Are you still somewhere
With your long legs
And twitching smile under
Your blue hat walking
Across a place? Or am
I greedy to make you up
Again out of memory?
Are you there at all?
I would like to think
You were all right
And not worried about
Monica and the children
And not unhappy or bored.

2
Speaking to you and not
Knowing if you are there
Is not too difficult.
My words are used to that.
Do you want anything?
Where shall I send something?
Rice-wine, meanders, paintings
By your contemporaries?
Or shall I send a kind
Of news of no time
Leaning against the wall
Outside your old house.

The house and the whole moor
Is flying in the mist.

3
I am up. I've washed
The front of my face
And here I stand looking
Out over the top
Half of my bedroom window.
There almost as far
As I can see I see
St Buryan's church tower.
An inch to the left, behind
That dark rise of woods,
Is where you used to lurk.

4
This is only a note
To say I am aware
You are not here. I find
It difficult to go
Beside Housman's star
Lit fences without you.
And nobody will laugh
At my jokes like you.

5
Bryan, I would be obliged
If you would scout things out
For me. Although I am not
Just ready to start out.
I am trying to be better,
Which will make you smile
Under your blue hat.

I know I make a symbol
Of the foxglove on the wall.
It is because it knows you.

Notes

Introduction

1 For discussions of the intellectual background for American painting in the period, see Steven Polcari, *Abstract Expressionism and Modern Experience*, New York 1991, and Michael Leja, *Reframing Abstract Expressionism: Subjectivity and Painting in the 1940s*, New Haven and London 1993.

2 Raymond Williams, *Keywords: A Vocabulary of Culture and Society*, London 1983 (1st pub. 1976), pp.219–24.

3 W.S. Graham, 'The Constructed Space' in *Collected Poems 1942–77*, London 1979, pp.152–3.

Chapter 1

1 Letter to Robin Treffgarne, n.d. [summer 1945].

2 Letter to his mother, 11 Aug. 1945.

3 Ibid.

4 Susan Murray, interview with the author, Wivenhoe, 10 June 1995.

5 Eric Wynter, 'Bryan: A Memoir', written for an exhibition at the Prema Project, Uley, 1984.

6 Eric Wynter, letter to BW, 30 July 1947.

7 Letter to Heddi Hoffmann, n.d. [summer 1942].

8 Eric Wynter, 'Bryan: A Memoir', 1984.

9 Ibid.

10 David Wright, 'Remembering B.W.' in *To the Gods the Shades: New and Collected Poems*, Manchester 1976, p.130; see also W.S. Graham, 'Dear Bryan Wynter' in *Collected Poems 1942–77*, London 1979, p.255, reproduced opposite.

11 Bernard Bergonzi, *Wartime and Aftermath:* *English Literature and its Background 1939–60*, Oxford 1993, p.19. The label 'St Ives' has come to define a particular group of modern-minded artists working in and around the town in the post-war years; I use the inverted commas to assert the fact that the label is a construct rather than a *de facto* group.

12 Letter to Heddi Hoffmann, 17 Dec. 1949.

13 Letter to his mother, 11 Aug. 1945.

14 John Heath-Stubbs, *Hindsights: An Autobiography*, London 1993, p.150.

15 'Comment', *Horizon*, vol.2, no.10, Oct. 1940, p.150.

16 Letter to Heddi Hoffmann, 13 Aug. 1945.

17 Letter to his mother, 6 Oct. 1945.

18 Letter to Heddi Hoffmann, n.d. [July 1942].

19 Dream diary, 17 April 1945.

20 Sven Berlin, 'MCMXLVI', manifesto for exhibition at Alex, Reid & Lefevre, London, Sept. 1946.

21 Dream diary, 1 Feb. 1945.

22 Letter to his mother, 11 Aug. 1945.

23 R. Morris Graves, *Wounded Gull*, 1943, repr. Clement Greenberg, 'Present Prospects in American Painting', *Horizon*, vol.16, nos.93–4, Oct. 1947.

24 Vera Hitchcock (née Leslie), interview with the author, 12 March 1993.

25 Sven Berlin, *The Coat of Many Colours: An Autosvenography*, Bristol 1994, p.207.

Chapter 2

1 Conrad Senat, 'Young English Painters: No. 1. Some Paintings by Bryan Wynter', *Counterpoint*, no.1, 1945.

2 Letter to Heddi Hoffmann, 22 Sept. 1946.

3 Erica Brausen, letter to BW, 16 April 1945.

4 Letter to Heddi Hoffmann, 22 July [1944].

5 Letter to Heddi Hoffmann, 1 Oct. 1945.

6 Letter to Heddi Hoffmann, 13 Aug. 1945.

7 Letter to Heddi Hoffmann, n.d. [?July 1945].

8 Wynter, letter to Heddi Hoffmann, 13 Aug. 1945; William Blake, *Auguries of Innocence*, in David V. Edman (ed.), *The Complete Poetry and Prose of William Blake*, New York 1982, p.490.

9 Graham Sutherland, 'A Welsh Sketch Book', *Horizon*, vol.5, no.28, April 1942, p.230.

10 Virginia Button, 'The Aesthetic of Decline: English Neo-Romanticism *c.*1935–56', unpublished Ph.D. thesis, Courtauld Institute of Art, University of London, 1991.

11 Letter to Heddi Hoffmann, 13 Aug. 1945.

12 Sir James Frazer, *The Golden Bough: A Study in Magic and Religion*, abridged edn. London 1922.

13 Erich Fromm, *Man for Himself: An Enquiry into the Psychology of Ethics*, London 1949, p.4; these issues were first set out by Fromm in *The Fear of Freedom*, London 1942.

14 Lewis Mumford, *The Condition of Man*, London 1944, p.399.

15 Aldous Huxley, *The Perennial Philosophy*, London 1946.

16 Berlin 1994, p.208.

17 Robert Graves, *The White Goddess: A Historical Grammar of Poetic Myth*, London 1948, pp.11-12.

18 Berlin 1994, p.212.

19 D.H. Lawrence, *Kangaroo*, 2nd ed. Harmondsworth 1950, pp.248, 263-4.

20 John Heath Stubbs, 'To the Mermaid of Zennor' in *Collected Poems 1943–1987*, Manchester 1988, p.311.

21 Wyndham Lewis, 'Round the London Galleries', *Listener*, vol.39, no.1011, 10 June 1948.

22 Hoffmann, letter to BW, n.d. [1948].

23 Stanislas Fumet, *Braque*, Paris 1945 (2nd edn. New York 1946).

24 Germain Bazin, 'Braque', *Braque and Rouault*, Tate Gallery, London 1946.

25 Patrick Heron, 'Braque', *New Satesman and Nation*, 4 July 1946, p.118.

26 Susan Murray, interview with the author, 10 June 1995.

27 Patrick Heron, letter to BW, 19 May 1951.

28 From a 1956 interview quoted in Frances Spalding, *Dance till the Stars Come Down: A Biography of John Minton*, London 1991, p.216.

29 Patrick Heron, 'Salon de Mai', *New Satesman and Nation*, 30 July 1949; 'English and French in 1950', *New Satesman and Nation*, 7 Jan. 1950; 'The Power of Paris', *New Satesman and Nation*, 19 July 1952.

30 Lawrence Alloway, 'Some Notes on Abstract Impressionism', *Abstract Impressionism*, exh. cat., Arts Council of Great Britain, 1958.

31 Franz Meyer, *Bram Van Velde 1957–67*, New York, quoted in Frances Morris (ed.), *Paris Post-War: Art and Existentialism*, Tate Gallery, London 1993.

32 Herbert Read, 'New Aspects of British Sculpture' in catalogue for the British Pavilion, Venice Biennale 1952.

33 Jean Paul Sartre, 'Doigts et non-doigts' in Jean Paul Sarte, Henri-Pierre Roché and Werner Haftmann, *Wols en personne*, Paris 1963, pp.10–21.

34 Patrick Heron, 'Introduction', *Bryan Wynter 1915–1975: Paintings, Kinetics and Works on Paper*, Hayward Gallery, London 1976.

35 Letter to Heddi Hoffmann, 13 Aug. 1945.

Chapter 3

1 Alan Bowness, 'The Paintings of Bryan Wynter', *Art News and Review*, vol.19, no.4, 14 March 1959.

2 Letter to Eric Wynter, 5 July 1956.

3 'Notes on my painting', *Bryan Wynter*, ed. Charles Lienhard, Zurich 1962.

4 Patrick Heron, 'London: John Wells and Bryan Wynter', *Arts*, vol.31, no.2, Nov. 1956, pp.15 and 73.

5 *Space in Colour*, exh. cat., Hanover Gallery, London, July 1953.

6 Ibid.; Clement Greenberg, 'The Crisis of the Easel Painting' (1st pub. 1948), in *Art and Culture*, Boston 1961, pp.154–7.

7 Patrick Heron, 'The Changing Jug', *Listener*, vol.45., 25 Jan. 1951, p.136.

8 Heron 1976.

9 Heron 1956, p.15.

10 Patrick Heron, 'London', *Arts*, vol.32, no.4, Jan. 1958.

11 'Statement' in *Statements: A Review of British Abstract Art in 1956*, Institute of Contemporary Arts, London 1957.

12 D'Arcy Wentworth Thompson, *On Growth and Form*, Cambridge 1942 (1st edn. 1917); quoted in David Thistlewood, *A Continuing Process: The New Creativity in British Art Education 1955–65*, exh. cat., ICA, London 1981, p.16.

13 Herbert Read, 'Art and Crisis', *Grass Roots of Art*, New York 1947, p.11.

14 Herbert Read, 'Art and Ethics', *A Coat of Many Colours*, London 1945, p.207.

15 Lancelot Law Whyte (ed.), *Aspects of Form: A Symposium in Nature and Art*, London 1951.

16 Rudolf Arnheim, 'Gestalt Psychology and Artistic Form', ibid., p.196.

17 'Statement' 1957.

18 Henri Bergson, *The Creative Mind: A Study in Metaphysics*, New York 1946, p.15.

19 Hadyn Griffiths, 'Bath Academy of Art, Corsham Court, Wilts., 1946–c.1955', unpub. MA report, Courtauld Institute of Art, University of London, 1979.

20 Henri Bergson, *Matter and Memory*, 1896, trans. N.M. Paul and W.S. Palmer, London and New York 1911, pp.76–7.

21 John W. Dunne, *An Experiment with Time*, London 1927 (republished 1929, 1934, 1948, 1958); that Wynter read this during the war was confirmed by Hugh Mellor, interview with the author 15 May 1995, and again in the late 1950s by Monica Wynter, interview with the author 14 June 1995.

22 'Statement' 1957.

23 Ibid.

24 Berlin 1994, p.209

25 Eugen Herrigel, *Zen in the Art of Archery*, trans. R.F.C. Hull, London 1953, pp.5-6.

26 Henri Michaux, *Miserable Miracle (Mescaline)*, 1956, trans. Louise Varese, San Francisco 1963.

27 Eric Wynter, letter to BW, n.d. [c.1956].

28 Aldous Huxley, *The Doors of Perception*, London 1954, p.17.

29 Ibid.

30 Graves 1948, p.20.

31 'Notes on my painting' 1962.

32 Note for Alan Bowness, 10 Jan. 1960 in *Bryan Wynter 1915–1975*, Hayward 1976.

33 'Notes on my painting' 1962.

34 Quoted in Tom Cross, *Painting the Warmth of the Sun*, Penzance and Guildford 1985, p.161.

35 Monica Wynter, letter to the author, 30 Aug. 1998.

36 Letter to Heddi Hoffmann, 13 Aug. 1945.

Chapter 4

1 Letter to Tate Gallery, n.d. [March 1966].

2 Ibid.

3 Richard Demarco, letter to BW, 16 April 1968.

4 Monica Wynter, letter to Tate Gallery, n.d.

5 Ibid.

6 Patrick Heron, *Bryan Wynter*, Falmouth 1975.

7 Michael Fried, 'Three American Painters: Noland, Olitski, Stella', 1965, republished in Michael Fried, *Art and Objecthood: Essays and Reviews*, Chicago and London 1998, p.224.

8 See Stephen Bann, Reg Gadney, Frank Popper and Philip Steadman, *Four Essays on Kinetic Art*, London 1966.

9 Roger Coleman, 'Introduction', *Situation*, RBA Galleries, 1960.

10 Letter to Tate Gallery n.d. [March 1966].

11 *Windows Through Silence*, film by Reg Watkiss, 1974.

12 Sven Berlin, letter to BW, 17 July 1956.

13 'Notes on my Painting', 1962.

14 Monica Wynter, interview with David Lewis and Sarah Fox-Pitt, 1981, Tate Gallery Archive TAV253.

15 Heron 1975.

16 Interview, *Cornishman*, 3 April 1969.

17 Theodor Schwenk, *Sensitive Chaos: The Creation of Flowering Forms in Water and Air*, trans. Olive Whicher and Johanna Wrigley, London 1965.

18 Ibid., p.99.

19 Heron 1975.

20 Patrick Heron, 'Bryan Wynter: Obituary', *Studio International*, vol.189, no.975, May/June 1975, p.228.

Select Bibliography

(in chronological order)

Conrad Senat, 'Some Paintings by Bryan Wynter', *Counterpoint*, vol.1, 1945.

Patrick Heron, 'Artists in Cornwall', *New Statesman and Nation*, 17 Jan. 1948.

Patrick Heron, 'London: John Wells and Bryan Wynter', *Arts*, Nov. 1956.

Alan Bowness, 'The Paintings of Bryan Wynter', *Art News and Review*, vol.9, no.4, 14 Mar. 1959.

J.P. Hodin, 'Bryan Wynter', *Quadrum*, no.9, 1960.

Patrick Heron, 'Bryan Wynter', *Studio International*, vol.189, no.975, May/June 1975.

Patrick Heron, *Bryan Wynter*, exh. cat., Falmouth School of Art 1975.

Alan Bowness and Patrick Heron, *Bryan Wynter 1915–75*, exh. cat., Hayward Gallery, London 1976.

Eric Wynter, 'Bryan: A Memoir', unpub. essay for Prema Project exh., Uley 1984.

Tom Cross, *Painting the Warmth of the Sun: St Ives Artists 1939–75*, Penzance and Guildford 1984.

David Brown (ed.), *St Ives: Twenty Five Years of Painting, Sculpture and Pottery*, exh. cat., Tate Gallery 1985.

Ellen Williams, 'Landscape – Perception – Abstraction: Bryan Wynter (1915–75) and his Artistic and Intellectual Milieu', unpub. MA diss., University of Essex 1987.

Rachel Tovey, 'Bryan Wynter's Graphic Vision: The Development of Abstraction in his Art c.1956–60', unpub. MA report, Courtauld Institute of Art, University of London 1995.

Photographic Credits

Arts Council Collection, London 6
Belgrave Gallery 45
Bob Berry 24, 28, 49, 50, 51, 60
Bristol City Museum and Art Gallery 23
British Council Collection 9, 44
Jonathan Clark 8
Fitzwilliam Museum, Cambridge 17
Government Art Collection 32, 57
Lincolnshire County Council: Usher Gallery 46
The Museum of Modern Art, New York 2, 30
Private collection 3, 4, 10, 16, 27, 29
Scottish National Gallery of Modern Art, Edinburgh 25, 39
The Suter Te Aratoi o Whakatu, Nelson, New Zealand (photo: Michael McArthur) 26
Tate Gallery Archive (photo: Edwin Scragg) 1, (photo: Roger Mayne) 7, 48
Tate Gallery (Photographic Department) 19, 20, 22, 31, 38, 42, 43, 54, 55, (photo: Bob Berry) 5, 12, 13, 14, 18, 33, 34, 37, 41, 47, 52, 53, 56, 59
Victoria and Albert Museum 15

Index